W9-CLZ-124

BLUE MOON OVER THURMAN STREET

To Charles and Patricia

Acknowledgements

To Homer Medica, Pat Miers, and all the people of Thurman Street who let Roger photograph them, talked with us, and told us stories and histories, our warmest thanks and good wishes.

Roger also extends special thanks to Joe Cantrell at the Oregon School of Arts and Crafts for technical assistance and editorial advice on the printing of the photographs.

Blue Moon over Thurman Street

Text copyright ©1993 by Ursula K. Le Guin
Photographs copyright © 1993 by Roger Dorband

All rights reserved. No part of this book may by reproduced or utilized in any form or by any means without permission in writing from the publisher.

Address inquiries to:
NewSage Press, 825 N.E. 20th Avenue, Suite 150, Portland, Or 97232

First Edition 1993, Second Printing 1994

Handwritten Poems by Ursula K. Le Guin

Book Design by Marcia Barrentine

Digital Layout by Greg Endries

Printed in Korea through Print Vision, Portland, Oregon.

**Library of Congress
Cataloging-in-Publication Data**

Le Guin, Ursula K., 1929-
 Blue Moon over Thurman Street / Ursula K. Le Guin; Roger Dorband, photographs. — 1st ed.

 p. cm.

 ISBN 0-939165-22-8 (pbk.) : $16.95

 1. City and town life—Oregon—Portland—Poetry. 2. City and town life—Oregon—Portland—Pictorial works. 3. Portland (Or.)—Pictorial works. 4. Portland (Or.)—Poetry. I. Dorband, Roger, 1944- II. Title.

 PS3562.E42B45 1993

 811'.54—dc20 93-30582
 CIP

BLUE MOON
over
THURMAN STREET

Ursula K. Le Guin

Roger Dorband, *photographs*

NewSage Press

Beyond our understanding is the changing form

of that tree; we do not know

its beginning, or its ending, or its roots.

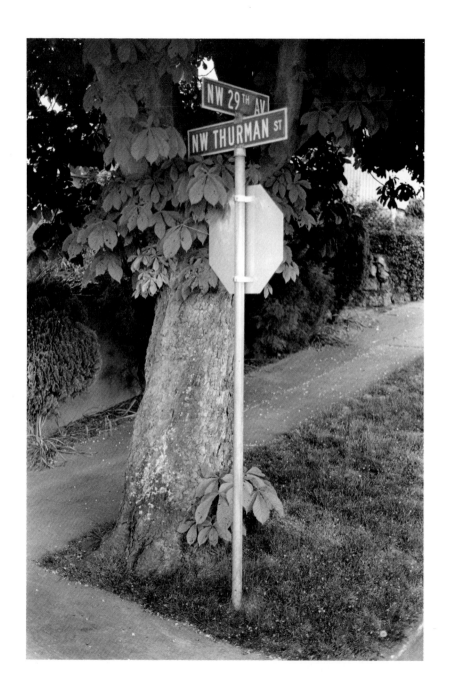

A Street That Crosses America

To walk a street is to be told a story.

Through the years that I have lived in Portland, as I walked up and down my street, Thurman Street, it kept telling me its story.

The story was never quite the same from day to day, season to season, year to year. Nor was I the same. In the sixties I was pushing a stroller and handholding a toddler as we took our daily walk down to spend a dime at Rodgers Variety or to pick a wild daisy from an empty lot. In the seventies the kids were up and down the street to school, and our pleasure-walks were up the street into the forest. In the eighties and nineties the kids on Thurman are other people's kids, and my walk is likely to be down to Food Front Co-op for something for dinner. And the street has changed and changed again. But it keeps telling its story. And the more I listened the more I thought, What an American story this is. This is a street that crosses America....

Thurman runs the money gamut and the social scale. It goes from rags to riches. It begins down among the docks and tracks and warehouses along the Willamette River and strikes straight through the Northwest Portland industrial district to a long stretch of small businesses and shops, increasingly mixed with apartments and modest residences, until it begins to climb the West Hills, leaping the gorge of Balch Creek on an old trestle bridge — a break, a surprise in the plot — and goes on up among big frame houses set back in gardens, beginning to turn and wind, passing a few fancy mansions, till at last it loses its name and its streethood, fingering out into miles of hiking paths, trailing off in the wilderness of Forest Park.

Not many streets get so far in about forty-five blocks: through all the urban conditions, from transient poverty, through heavy industry, through small businesses, to established wealth — from railroad tracks under great freeway pylons, past windows of little shops and grocery stores, to the shady, flowery front gardens of comfortable homes — from hi-tech to old growth in one morning's walk.

Oregon is the only state in the Union that people in the East pronounce wrong, evidently to show how foreign to them it is — a remote, green place "out there" where nobody ever doesn't recycle. The West Coast is certainly a different place from the Eastern Seaboard; but all you have to do is leave the United States to realize how gen-

uinely they are one country, and for all their splendid differences, one community. Portland isn't a typical American city, because there is no such thing; but it has pretty much what most American cities have, and it does, in its own way, what American cities do. It's unusual in being a major seaport inland, on a river. Big ships come up the Columbia eighty miles to the Port of Portland on the Willamette River just above its confluence with the Columbia. Grain, lumber, cars sail in and out, and tankers get repaired at the biggest drydock on the West Coast. The Willamette (an Indian name despite its French spelling: not willaMET, but wulLAMMet) curves beautifully right through the city, crossed by eleven bridges, which are crossed by ever-increasing numbers of commuters during the ever-longer rush hours. Of the five great West Coast cities, the northern four, San Francisco, Portland, Seattle, and Vancouver, B.C., have much in common, in looks and in mood. They are ports, built on hills above the water, their skies are often grey and their winds cool, they have compact, lively, walkable downtowns, and people live in them, not only in the suburbs.

Like Seattle and Vancouver, Portland is the only big city in its state. Each is the real center of a huge area, not yet heavily populated, where the economy is the scenery, what comes out of it and what goes into it. In Oregon mostly it's been timber, fish, wheat, electricity, and tourists. As the forests are clear-cut and the ocean trashed and the salmon killed off, this Third World economy gets shakier. The so-called tax revolt of the eighties is doing immense damage to Portland by withdrawing support from human services, park maintenance, the library, the

arts, the schools, tearing apart the network of community. In all this, the city is like most other American cities. Most of them aren't built on a bunch of extinct volcanoes, as Portland is, and don't have several snow-crowned active volcanoes on the skyline, as Portland does; but the deep geology of our society is the same right across the continent. Times of upheaval, when the ground of society shakes, when chasms open in the street, we all live through them together.

The first two decades my family lived on Thurman, it didn't change much or fast. Food Front, which started out

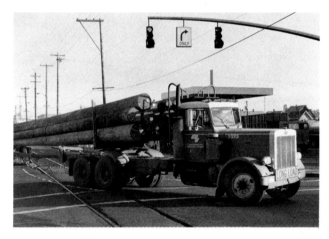

in deep hippy funk, moved three times, each time getting bigger and classier. The funny little old candy shop closed down; a few shops came and went; but the Twenty-third Avenue Market, the bars, most of the businesses, seemed permanent. The empty lots were full of nodding wild grasses and half-grown trees. Somebody painted their house or fixed their roof, and somebody else didn't. Everything was the way it was. Until the eighties, when it began not to be the way it was.

This book is not primarily a record of that change. Our intent was not to do a history, but a story: to try to catch not the losses and gains but the permanence. The only way to catch permanence that I know is to catch the moment. When we began this book in the mid-eighties, we did not know that the moment we were catching was, in fact, the moment of change.

What we were after was the story Thurman Street was telling, all that vigor and variety of aspect and season, of motion and intention, of building and decaying, of business and loitering, the lonesomeness and the sociability, the life of the street. And I think that story is in this book. But another one began weaving itself in, during the years it took us to get the pictures and the words we wanted.

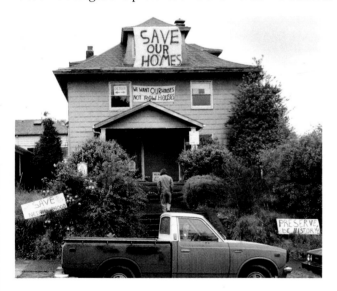

Two major transformations came in the late eighties. Our pictures show Thurman running direct from the river up into the hills. It no longer does so. Freeway access has one-wayed it below 21st Avenue, cutting off lower from

upper Thurman. This discontinuity seems to me to reflect with terrible literalness what happened to American society in the 1980s: the deepening of a gulf between the poor and the rich, and the acceptance of that gulf — the denial of ways to get across it.

The other change was the coming of the rowhouse entrepreneurs and the gentrification/yuppification/upscaling of the long central stretch of the street. The rowhouse, well built, is an excellent solution to urban dwelling; but the exploitive arrogance of "developers" knocking down good old houses to build shoddy new ones led to a neighborhood crisis. Tenants of one of the rows probably don't know that in the cement of their foundations the words BAD KARMA are indelibly engraved. When some fool took advantage of the climate of anger to set fire to the half-finished buildings, the nonviolent protest movement was stymied; but it was not ineffective in the long run. The old houses of the neighborhood are being renovated now, not bulldozed, and some of the renovations are very fine.

We have recorded some of these dramatic changes in recent pictures of sites photographed earlier, Then and Now pictures — just to hint at the next plot development of the Thurman Street story.

The empty lots in our photographs have all been built on. Some of the businesses have closed, others have upscaled or rebuilt, others have not changed a bit. The top and bottom ends of the street look very much as they did five years ago, or ten, or twenty years ago — only, as I said, they seem farther apart than they used to. But Norm Thompson's still encysts its great tweeds and trendy running shoes under the freeway in the very heart of grot, and the 32nd Avenue Fountain, with its separate

provision of water for people, horses, and (low down on the outside) dogs, still runs, and still gets squirted at hapless passersby by boisterous kids. The more it changes the more it's the same. Except, maybe, for the trees.

Northwest Portland began as Stumptown: a pioneer clearing hacked from interminable forests. And so it goes on. All too often, the city's great trees are felled by real-estate exploiters or cut down by the city itself for "convenience." All we could do was record, and grieve. And recently the work of consciousness-raising by groups such as Friends of Trees, Friends of Forest Park, and the Urban Greenspaces movement gives hope that Portland will cease to commit suicide by chain saw.

In this, again, we see America reflected. There was a forest, once, from Maine to Georgia, from the Atlantic seaboard to the Mississippi. Where is that forest now? Gone where the forests of the West are going. But when I called Forest Park "old growth," I was taking poetic license. Forest Park — the largest urban wilderness in the country, with seventy miles of trails through the big firs — is second growth. It was logged early in the century. The beauty of it and the lesson of it is that it was allowed to grow again, unhelped, unhindered. It's on its

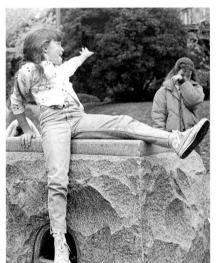

way now to being old growth. Just give it a couple hundred years. It has begun to tell us its own long, long story, if only we'll listen.

A street that ends in a forest — there is a magic there. All our streets began in the forest, once upon a time.

When we started working on this book, I had lived on Thurman Street for over twenty-five years, and Roger was living a few blocks south of it. The photographs came first. Roger took his camera and walked the street, on and off, summer, winter, day, night. He took pictures I asked him to take, and pictures he wanted to take. A tall, strong man, he went about at times to places that I, a short, cowardly woman, wouldn't dare go; so he showed me aspects of Thurman that I had never seen. Also, we see the same street differently. That's why this is a true collaboration. Roger's Thurman Street is bluer and darker and bleaker than mine; it has more cars and more power lines. My street has more kids, cats, dogs, and housewives than his. Naturally, the street in our pictures is Roger's street, but it's mine too, in the words, and in the trees and the houses and the faces, the wonderful faces of neighbors you see every day and once in a blue moon.

The photographs came first: that's how I wanted it. I wanted to respond to them. Very soon I saw that their strength of mood and image forbade a chatty, explanatory text, and that my response would have to come from the heart.

In the Notes on the Photographs in the back of the book, we tell when the picture was taken, where, what, or who it is, and often something about why it was taken, what was happening, or what's happened there since. To accompany the pictures themselves, what I tried to make was a line of words that would run along with them, interconnecting

them, like the pavement that runs past the shops and houses of the street.

I began by writing a poem for each photograph, reacting directly to the image and finding links and resonances with other images. Then I took to writing down things that I heard said on Thurman Street. I'd overhear two adolescents talking, or a group of workmen peering into a big hole they'd made in the street, and I used the writer's equivalent of the candid camera, which you might call the candid notebook: I wrote down what I heard. Meanwhile, Roger was getting into conversation with some of the people he photographed. He was so fascinated by what the owners of the Twenty-third Avenue Market and the Thurman Street Bookseller told him that I went with him and wrote down their stories and got their permission to put them in the book. Stories are everywhere if you listen. And they were all part of the story of the street.

As I worked I began to seek some voice that was not mine nor my neighbors', a voice speaking from beyond this-time-now, this-place-here: words of the eternal story, to bring it all together. I found this voice in the Indian sacred book, the *Bhagavad Gita*, which in its austere tenderness acknowledges all chance and change, including them in stillness. So the three voices — my own, my neighbors', and Krishna's — interweave in time and out of time, as do the voices and the lives along the street, along the years.

The order of the photographs is that of a walk up the whole length of Thurman Street. We weren't strict about this. We zigzagged a bit, and looked back over our shoulders. The idea was to invite you to come with us, moseying along the street, letting it tell its story from the railroad tracks to the snowy doors of the forest, going west. Most Americans feel easy going west. And going that way takes us back in time as we go forward, too. We climb up from the recent. The old houses lead us to the old trees, up in the hills that rise above the river older than them all.

Ursula K. Le Guin

Photographer's View

By Roger Dorband

Before Ursula and I began the "Blue Moon Project," I had never walked the length of Thurman Street. Mainly I knew it through the window of my van, making regular runs to Food Front Grocery and dashes to the freeway when lower Thurman still served as an extended on-ramp. I thought of the street as an artery flowing between two hemispheres, the residential neighborhood to the south and Portland's sprawling industrial district to the north.

When I began to walk Thurman Street and photograph it, at first I felt vulnerable and conspicuous. There was very little foot traffic. Northwest Portland streets run alphabetically, A to Y, and I lived on Irving. I felt out of place, an interloper. Every time I approached a fellow pedestrian I could hear them thinking a block away, "Here comes a man with a camera."

But self-consciousness lost relevance early in the project after an encounter I had outside the Swift Mart. There I photographed and talked to an elderly man wearing a baseball cap and coveralls, who was picking up recyclable cardboard. In a raspy voice he informed me that he wouldn't live on Thurman Street. "Too much trash." He paused. "You can get killed down here." I had assumed he meant litter.

My real concerns as a photographer surfaced as the negatives and contact sheets began to pile up. How was I to make a cohesive body of work from a street as diverse as Thurman, where I found a drug house on one corner and a rose garden on the next, industrial riprap, space and freeways at one end and deep forest at the other? If there were a building tall enough for an overview shot, that might help make sense of it. But there isn't.

So Thurman has to account for itself with no apologies for its changeable nature. I have tried to present it as it appears to the pedestrian, always from street level, from the outside looking in. There are only a few exceptions: one photograph from the window of my van, another from a front porch, and one literally in the shadow of Thurman Street. In keeping with my basic notion I photographed only with available light and used a lens range that mimics the way the eye sees, never telescopically or panoramically. I hope you enjoy the walk.

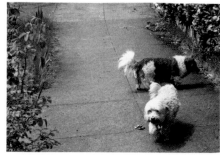

BLUE MOON

over

THURMAN STREET

Thurman Street
is sideways to the river
and the railroad tracks.
It brings the river
and the hills together.
But down here
nothing is together.
Empty air under things
too big. It's lonesome.

When the Indians lived around
here down Thurman,
they lived in houses
with fireplaces.
I guess it smelled like cedar smoke
and salmon, then. I guess it was only
relatively lonesome.

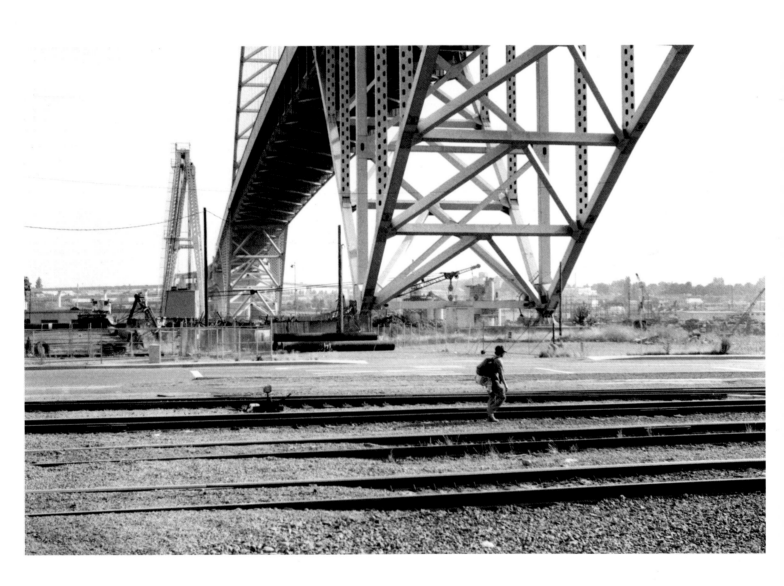

Down here
The paint flakes off and peels off and
goes random and the stairs
are shadowstairs. The warehouse doors
admit no wares, and the Industrial
goes all to seed, relaxing
into dust, desuetude,
going backwards.

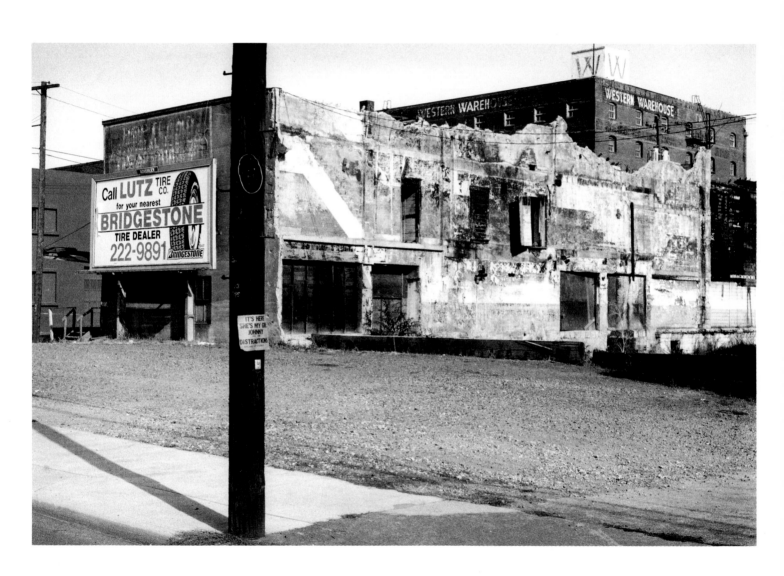

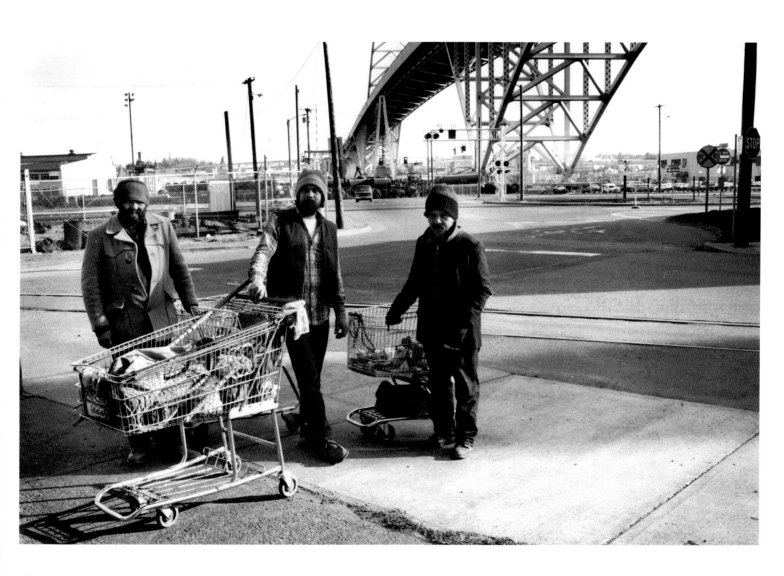

It is well to know what doing is,

what wrong doing does,

what not doing undoes.

The way of doing is mystery.

What is doing? What is not doing?

Even the wise must wonder.

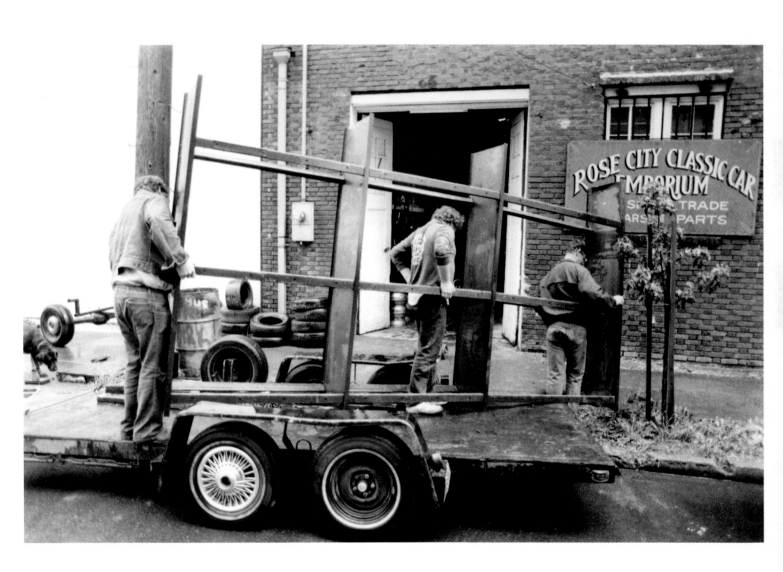

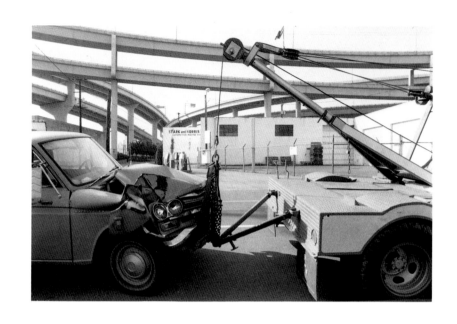

Cars can't see.
Overpasses, freeways
are for the blind
staring with glass eyes,
speeding unseeing.

Below them sideways
going nowhere
a painter stands
holding vision
in her hands.

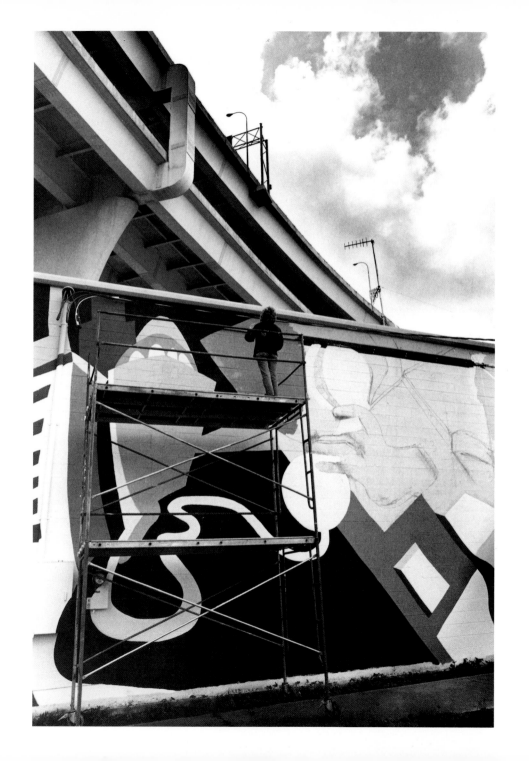

23

Car-bones.
Auto-skulls.
Airsockets
watch, keep
watch. STOP!
says the watch
dog behind the
gate-bones.

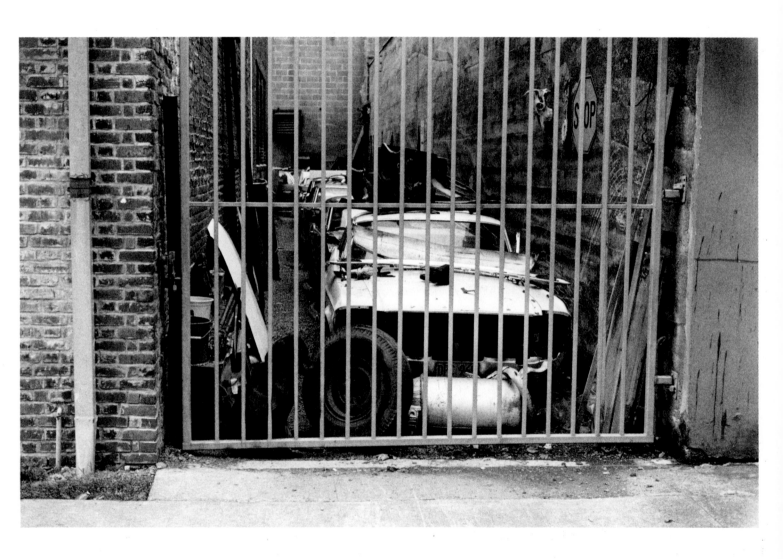

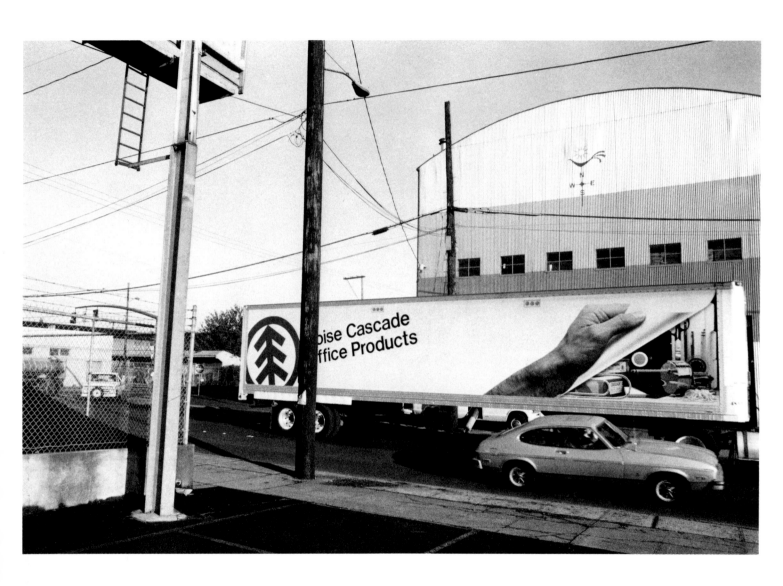

Back then
any path was here
went sideways
edging along the hill between
trees between creeks.
Most likely
wasn't any path here.

for deer
deertrails.
To dewberries
no trails.
Souls take
their own ways
sideways.

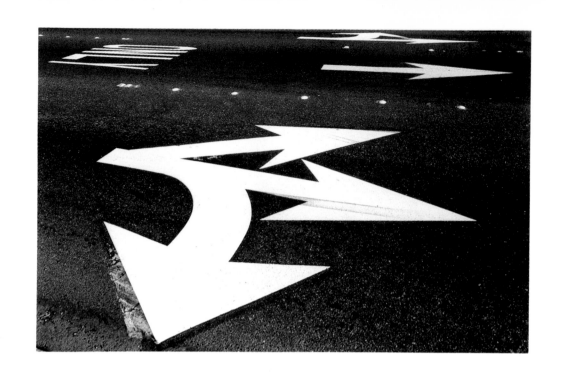

Street of the city of Portland OR
Somewhere :
 street laid out
straight to
go straight to
go fast to
go somewhere or
other

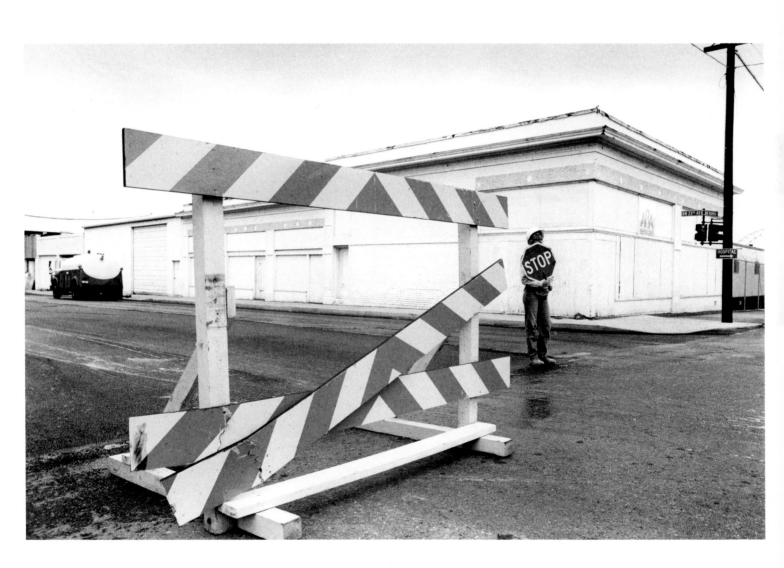

Blues

There's a blue moon
Blue moon over Thurman Street
in a month of
Sundays

Gonna see my baby
Gonna give her a call
on the Telephone
say Baby I'm all alone

And it's a blue moon
in a month of
Sundays
Oh baby come on down

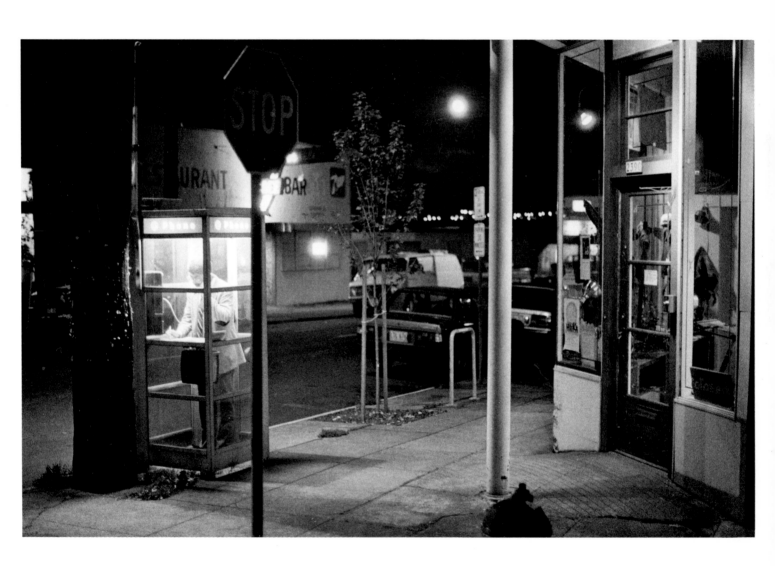

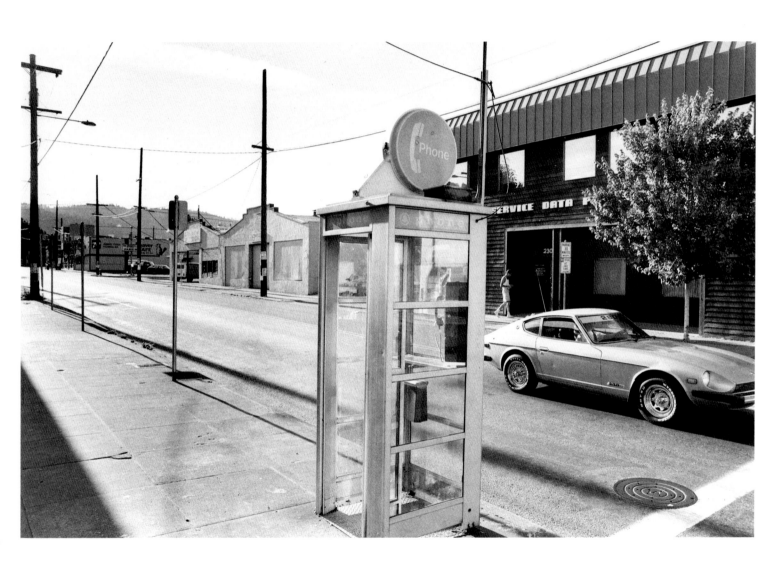

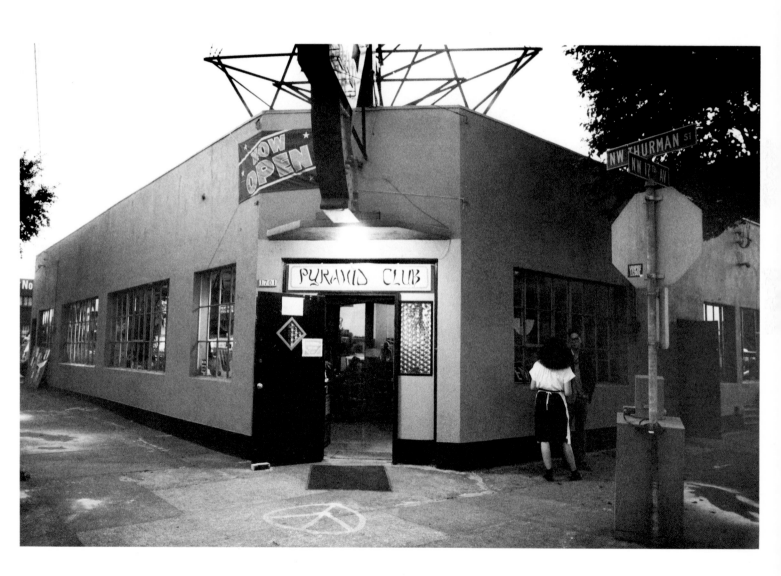

33

Rainblues

Street like a river
in the rain
coming, coming down, rain going
to rain
in the rearview mirror,

same rain
fell last night,

next year,
some year.

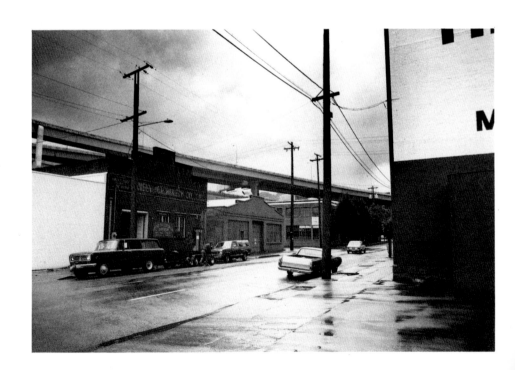

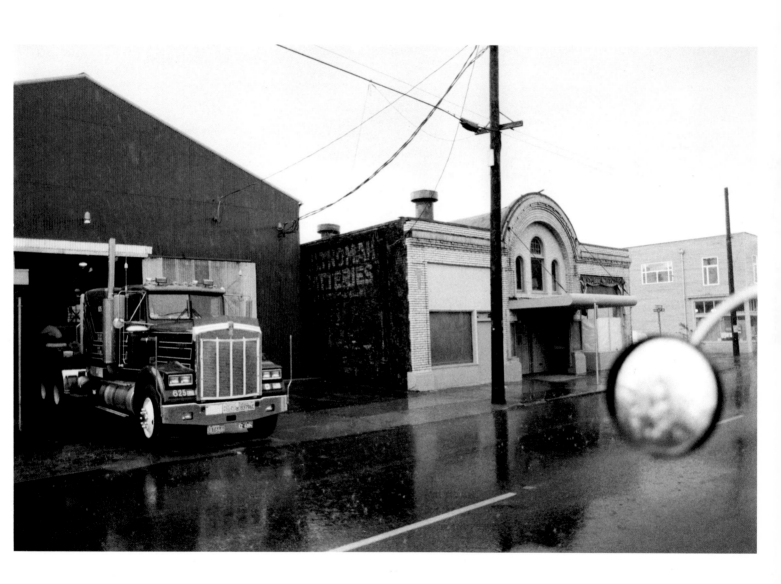

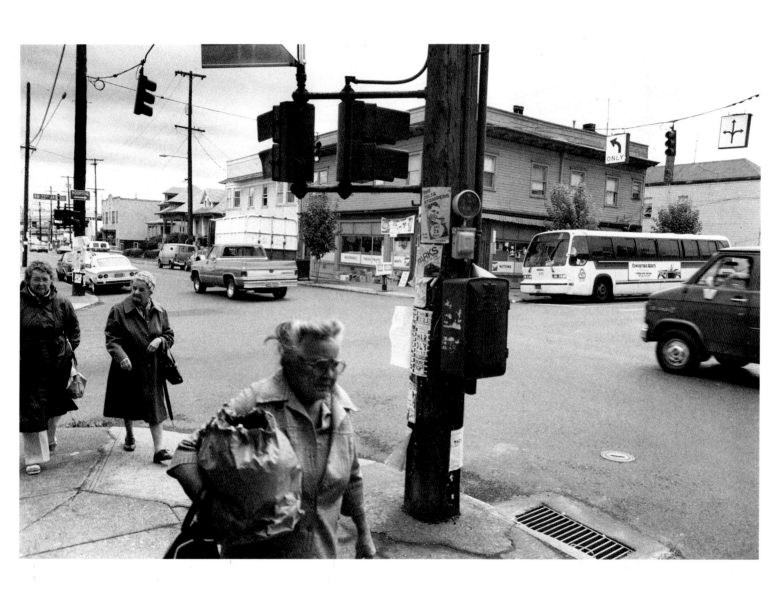

Streetblues

Street like a river
lives like fish
 minnowkids flash by
 troutsouls rise
 everybody's nose
 upstream
Street like a riverbed
lives like a river
 busy noisy
 on the run
 going on going
 downstream

Gameblues

Gonna win it, yeah
Gonna win it, yeah
Gonna play it, gonna win it
Watch me win it, yeah

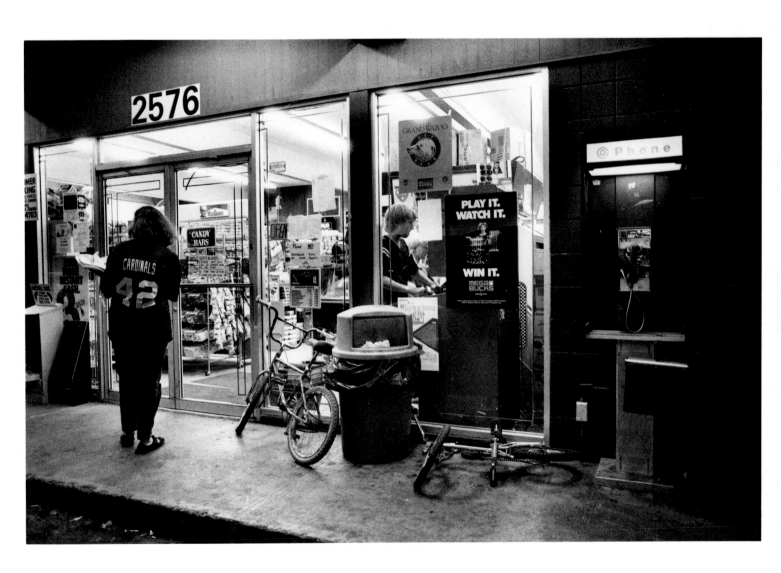

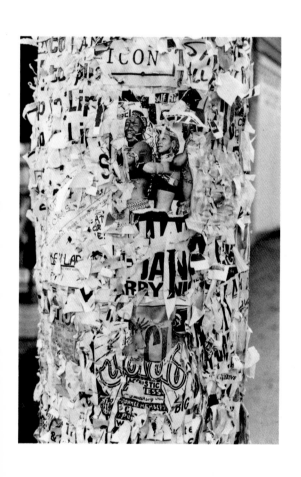

Bus Stop Blues

Look away
look away from love
Oh look away

if you're the lonely one
don't have a man to hoed you
don't have a woman to hoed

you have to look away
look away from love

waiting for the bus don't ever
ever seem to come

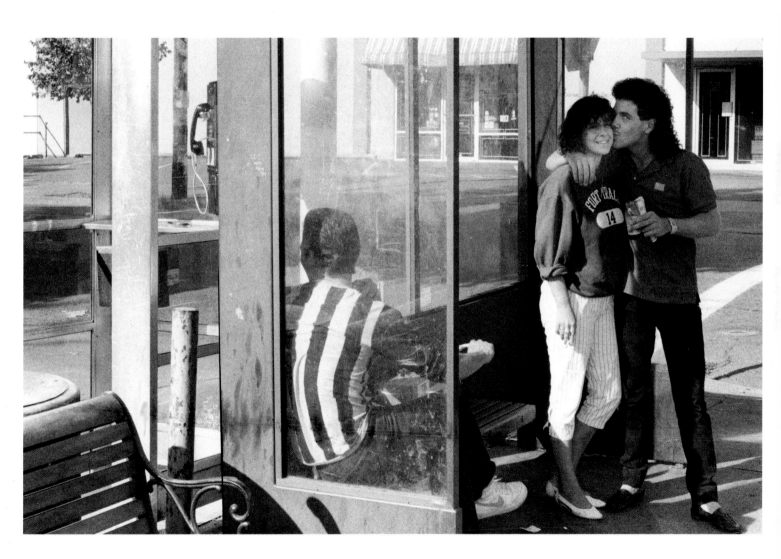

Pat's Blues

"There were about five people in the store. It was winter time, in the afternoon. This lady had on an overcoat, and she looked like everybody else. She was in her thirties, maybe thirty-three. The other customers had all gone out, and she called from the table back there that she couldn't find the price of some book.

"I went to the table. I had on my felt hat, my winter hat, and I was leaning over to see the price in the book. She grabbed my hair and pulled my head back and stuck the point of the knife at my throat. I said, 'What are you doing?' I was just as calm as I could be....

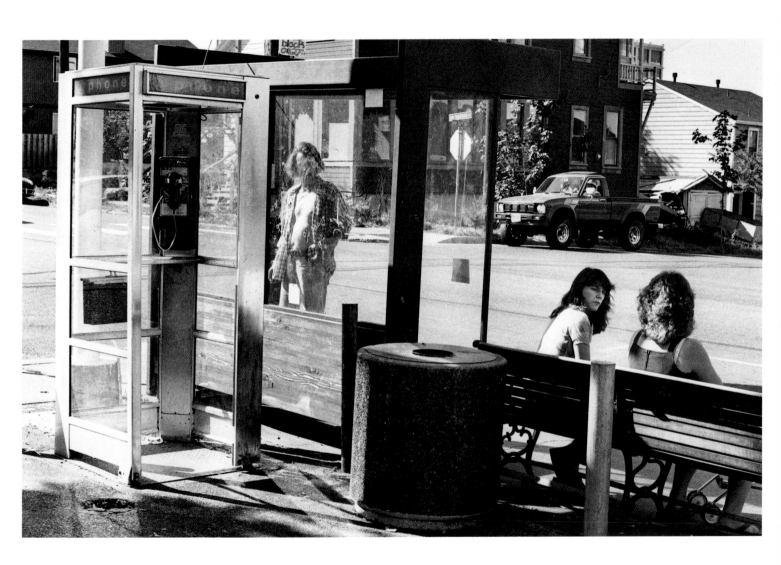

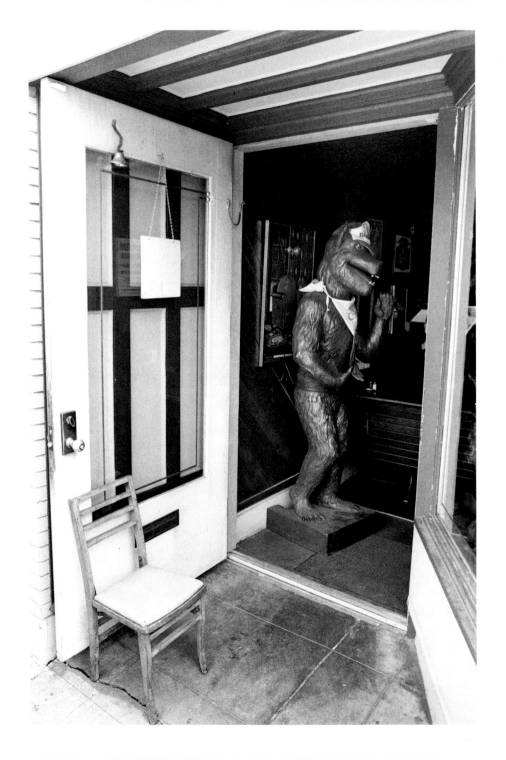

Pat's Blues

"… She says, 'Get down! Get down!' And I said, 'On the floor? Why do you want me to get down on the floor?' That started her screaming — 'Get down on the floor!' And she started cursing, saying terrible things.

"So I got down. And I looked under the table for some kind of weapon, but there were only some records and gourmet magazines. I was thinking that she had mistaken me for somebody, that I looked like somebody she knew, and that she was crazy and was going to kill me. She said, 'Don't move,' and she made me repeat it — 'I won't move!'

"Then she went to the cash register, up front there. And when I heard the ding! of the register, you know, I was so relieved. I knew she wasn't crazy. They're addicts, you know, they need their fix. Well, then, when I heard her getting the change, the small change out of the register, the pennies! Well, I thought, 'Okay!' And I ran for the door, and I got out, and got next door to the beauty shop, and said, 'Call 911!'

"She had started out after me. But then she saw that there she was, out on the street waving this huge butcher knife. So she went the other way."

So the warrior Arjuna finished his lament

and said, "Krishna, I will not fight!"

and then was silent.

And Krishna smiled....

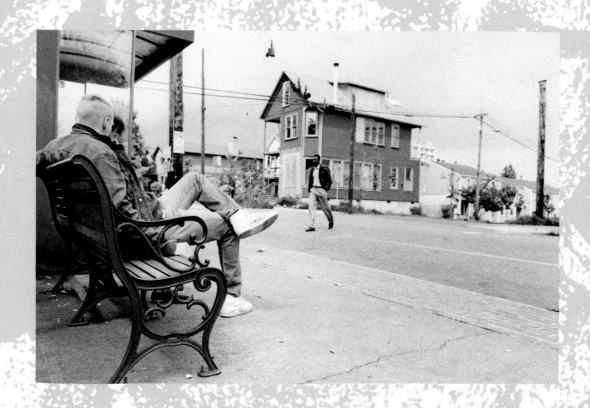

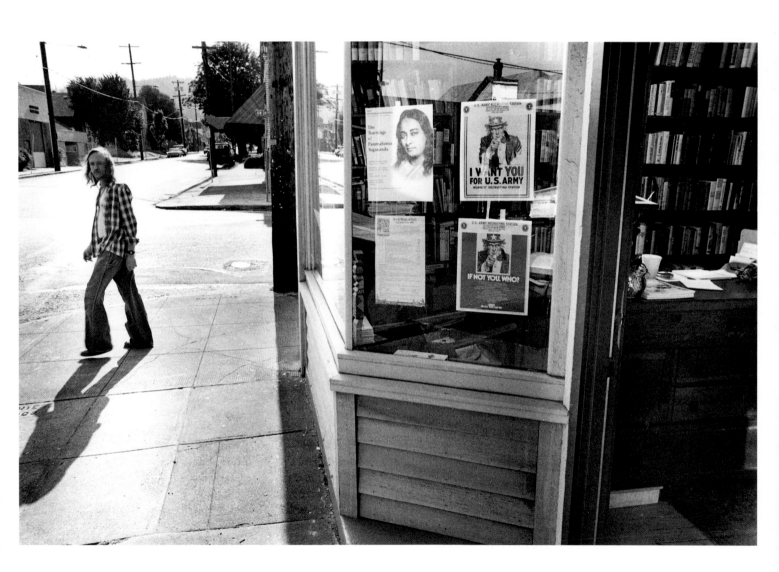

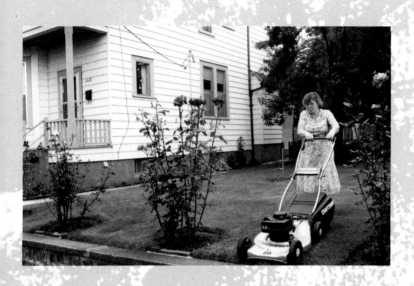

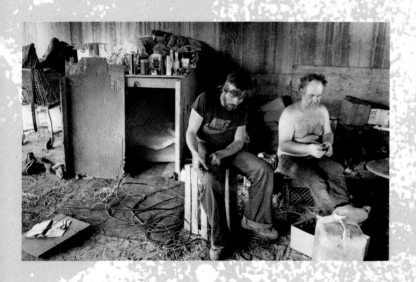

To know not doing is doing

and doing is not doing:

this is true wisdom,

this is to find peace.

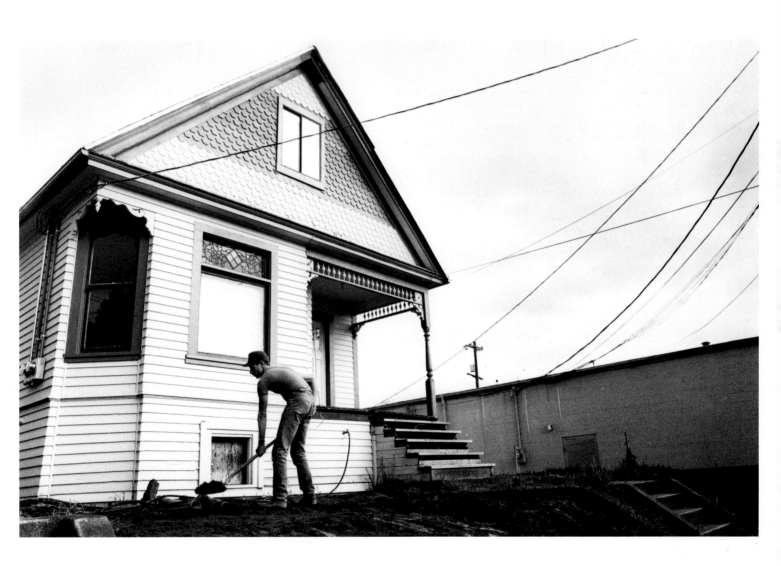

Doorway between
working in the indoors
walking in the outdoors
 between getting along
and getting away
 between faces
and a back
 between in deeper
and on out:

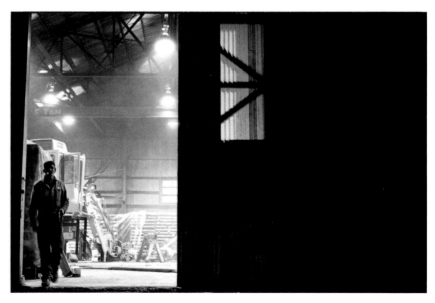

"All being is seen between
two unseens"

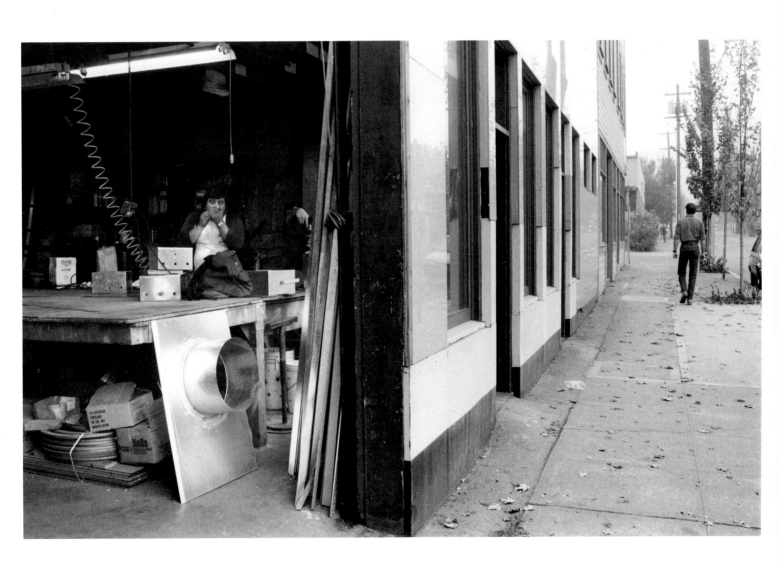

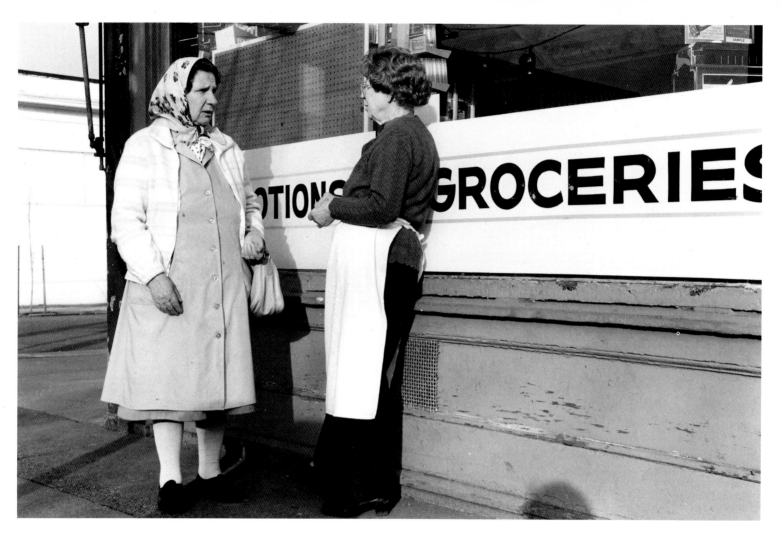

Homer's Blues

"Every corner had a store on it — 23rd here, 24th, 25th, and down the street to 19th — in the thirties and forties. There were groceries, and hardware stores, and little restaurants, and drygoods stores, and bakeries….

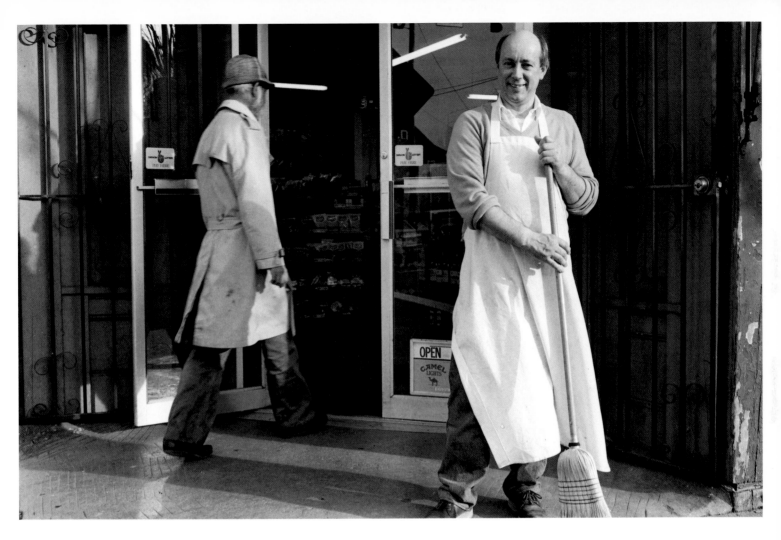

"And the rest of the street was all houses and apartment houses, and there were apartments over most of the stores. At nine at night, in 1943 or '44, Thurman Street was more crowded than downtown is any time today. People were everywhere. . . .

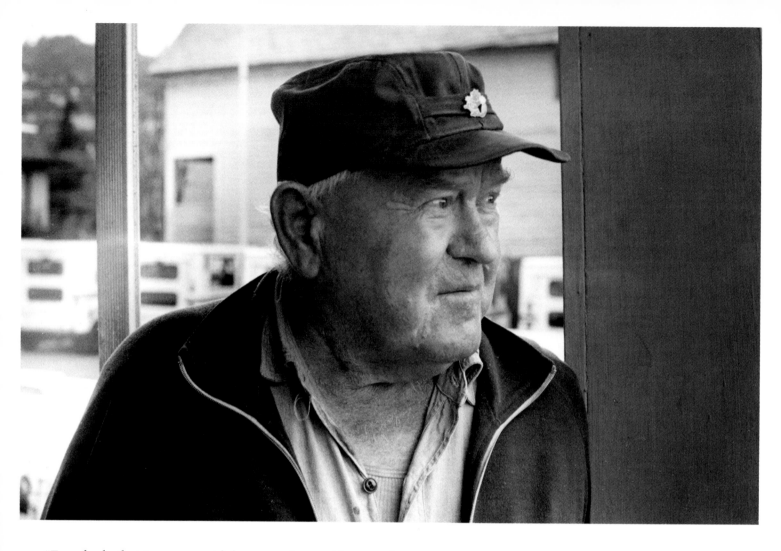

"Everybody that I grew up with has moved away. Not out of town. Across town, mostly. But moved away."

—*Homer Medica*

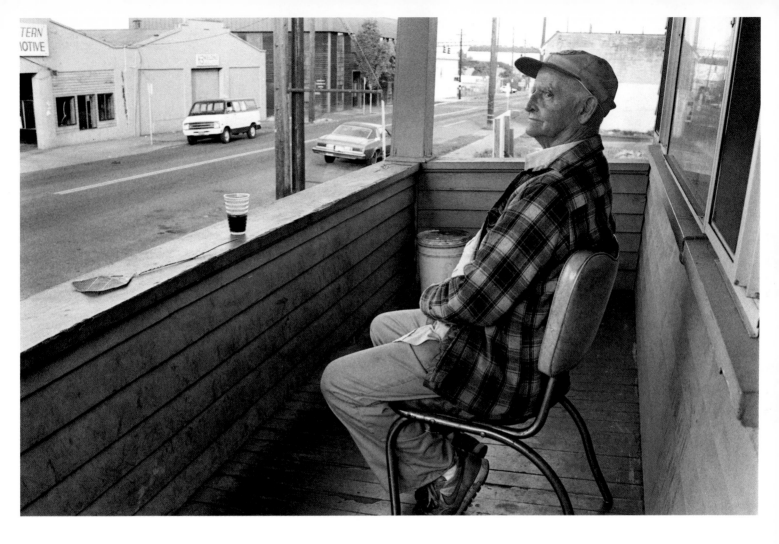

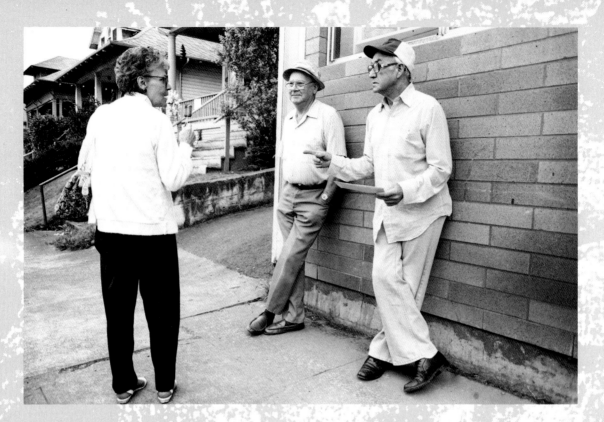

When I see your gentle
human face, my Lord,
I return into myself
and my heart is peaceful.

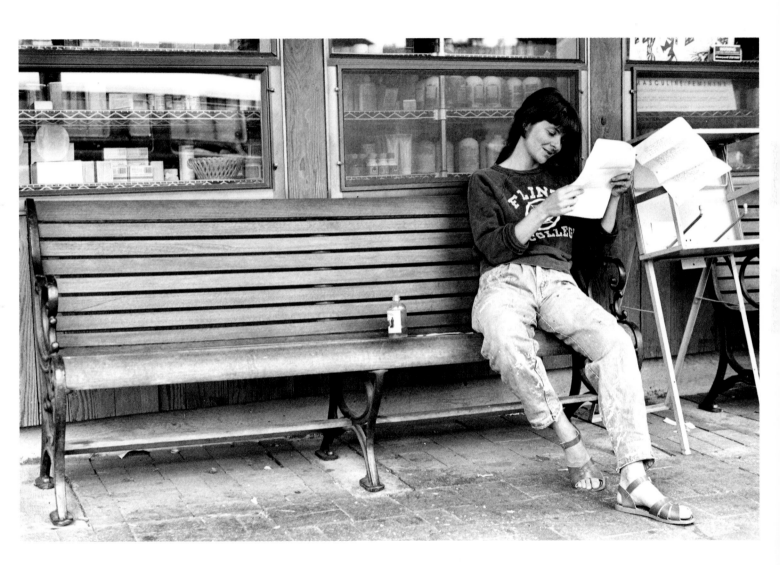

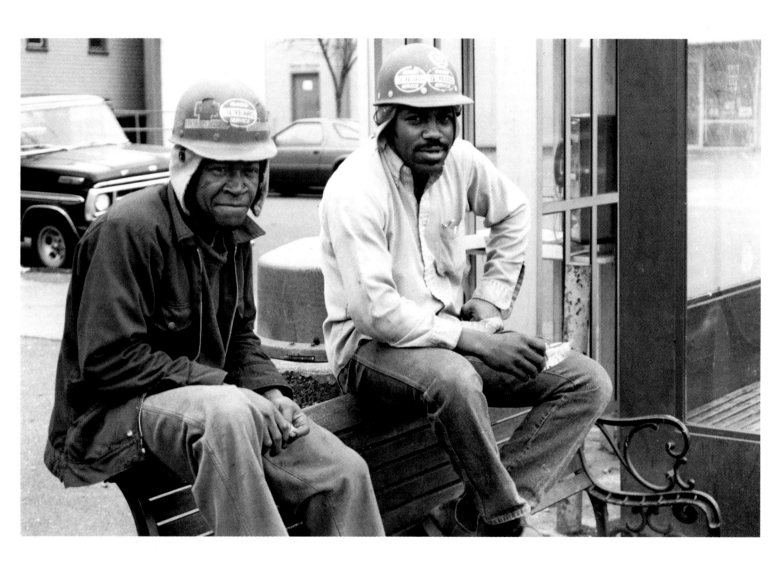

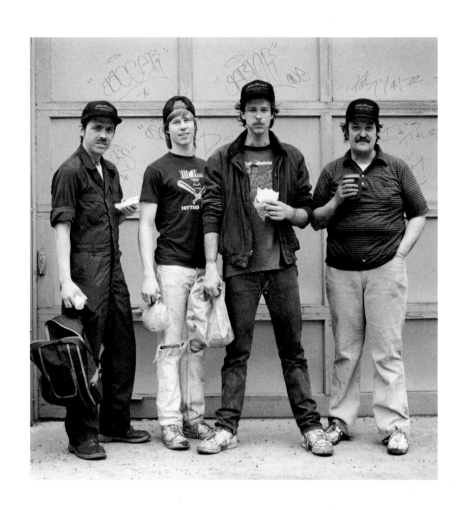

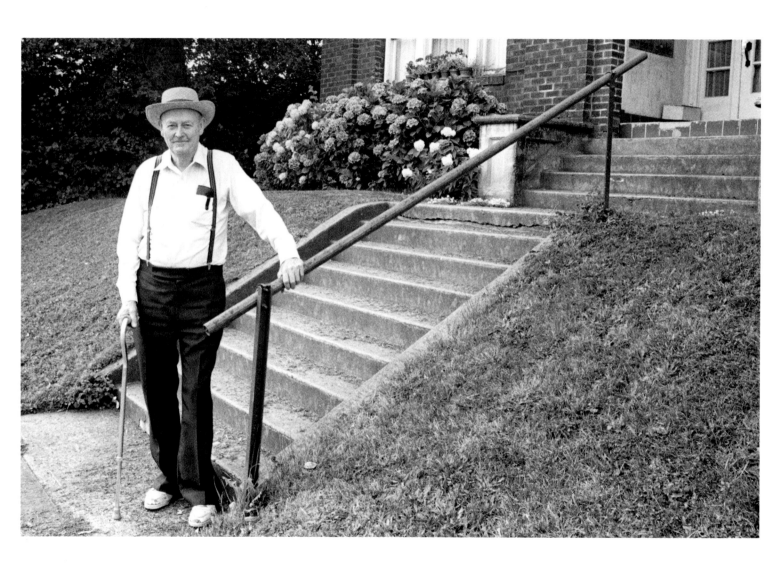

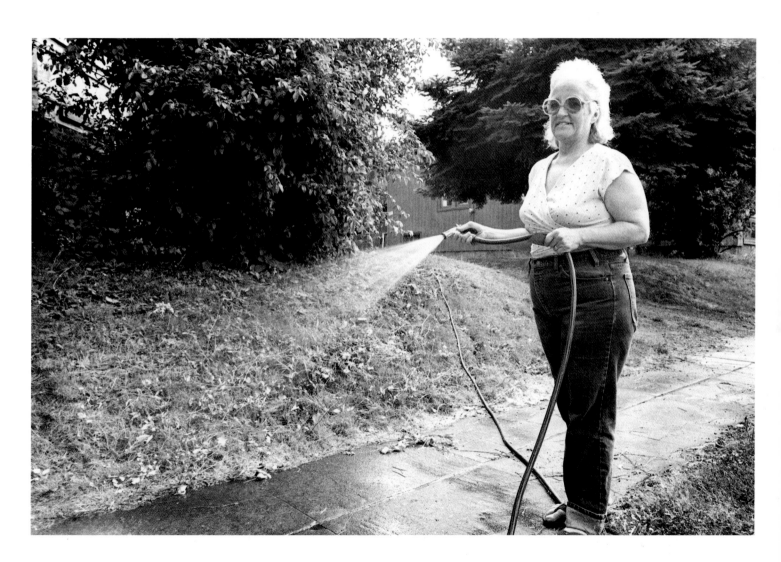

Teenblues

"This is the last thing
that'll happen to me
 I hope.
When I told my mother,
she said —
'If anything
else ever
happens to you —!'"

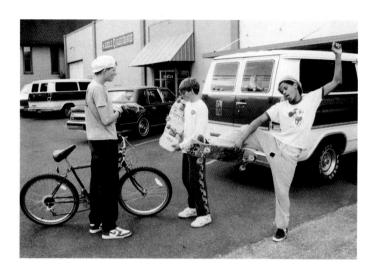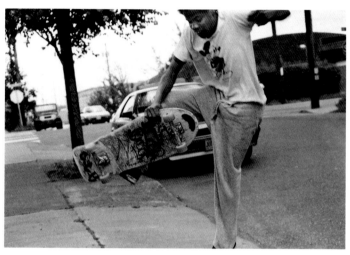
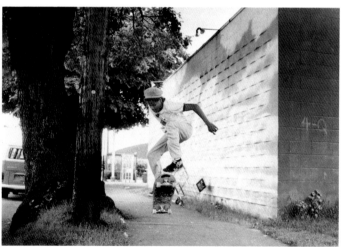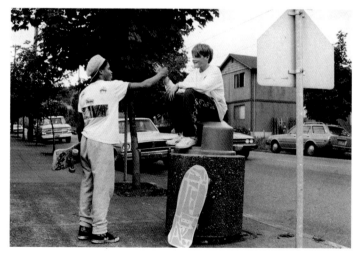

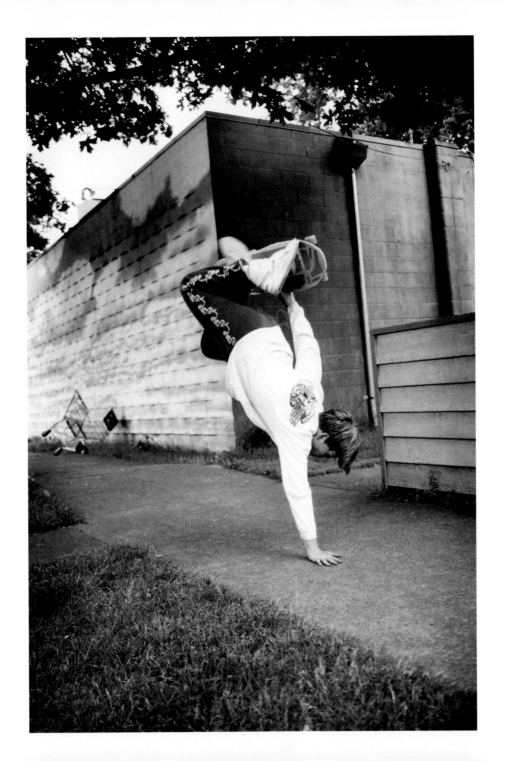

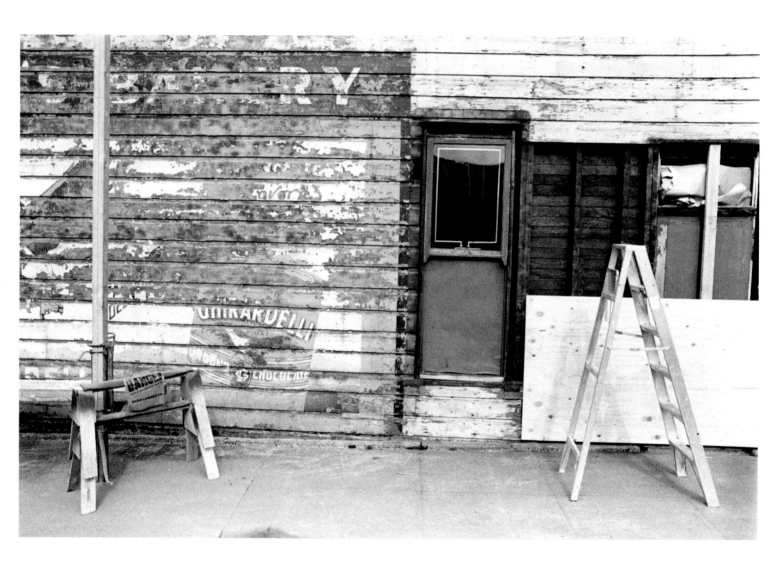

"There were groceries
and hardware stores
and little restaurants
and dry goods stores
and bakeries . . . "

The door admits
no one, no wares.
 The ladder
climbs air to where?

Any path was here went
sideways between trees. Now
there's grass in the window,
child in the grass, house
in the glass
house
where trees sprout
from chairs and where
is here when out
is in, in out?

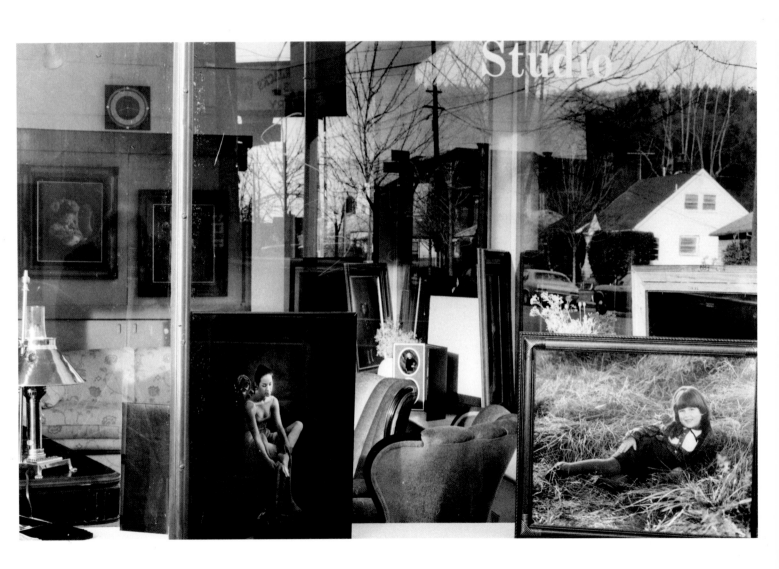

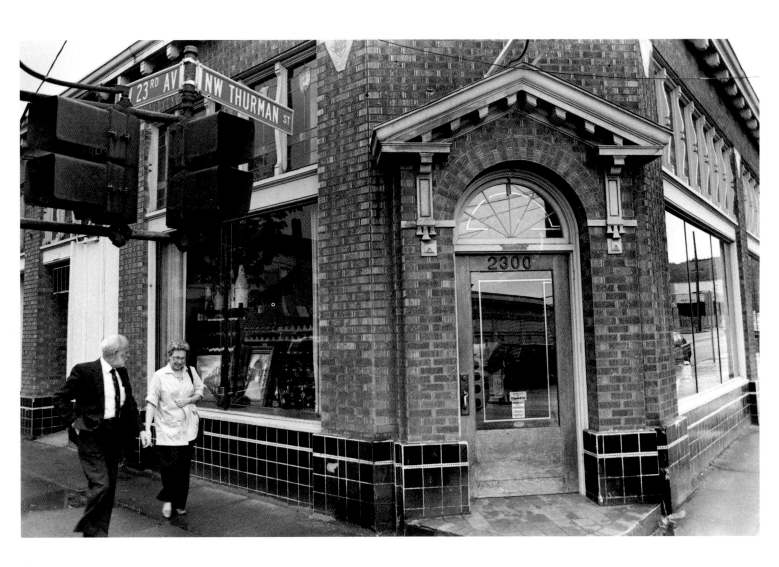

Here, now, a dignity
of brick, of tile,
arch and pediment, Vic-
torian solidity.
A good vintage.

The community gardens
brought forth the fruits of the earth
and they were shared out on tables
under the great horsechestnut tree that bears
the fruits of the middle air
That are not the food of this body.

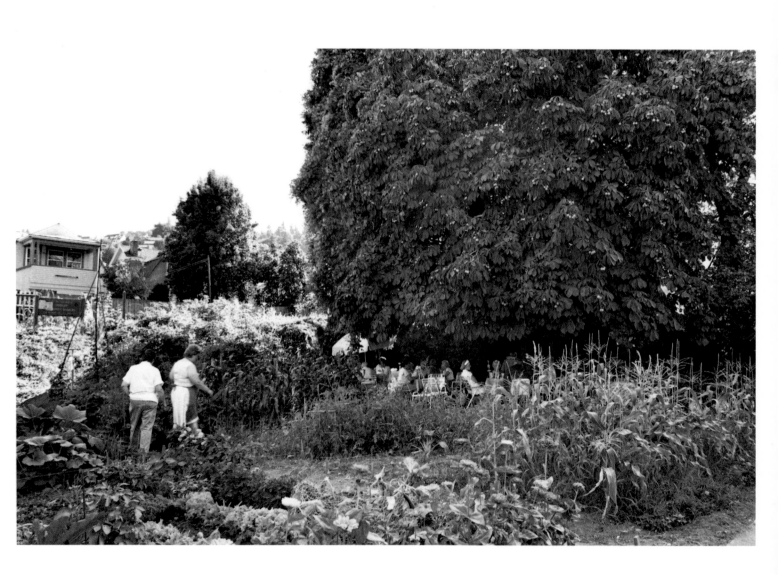

In the East living in cities
without any empty lots
I went stir crazy.
Life without weeds
isn't life, it's a product.

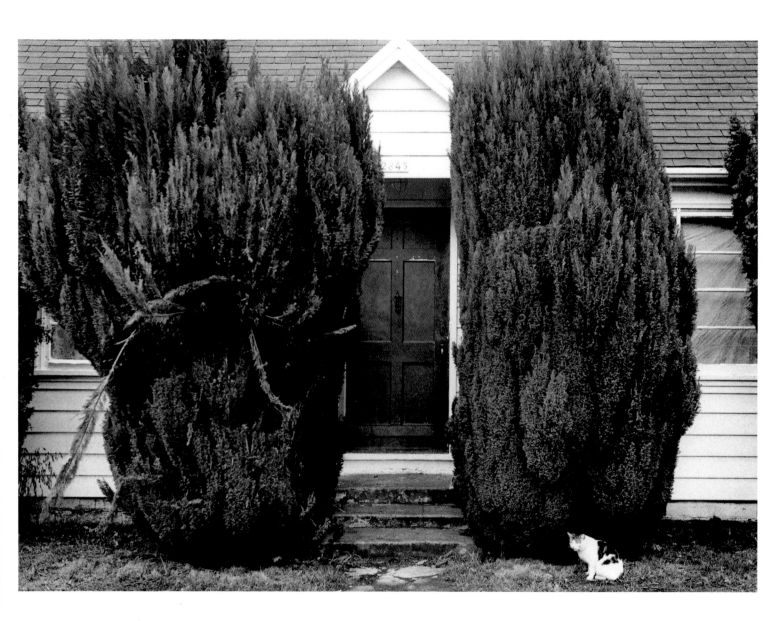

This cat
is thinking twice,
I think.
Or these two yews
have had one
small, indecisive
thought
between them.

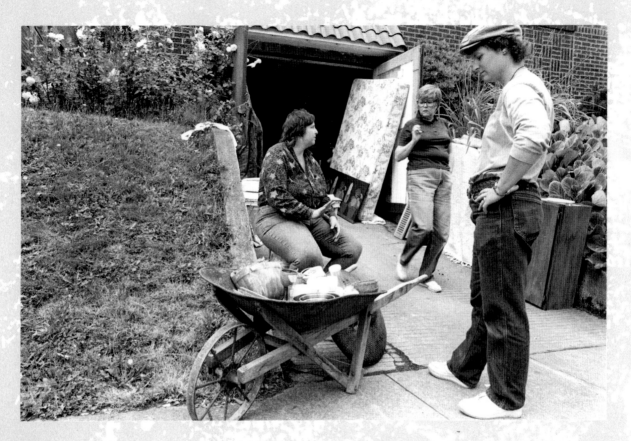

The delight of the things of the world

bears its own sorrow in it.

It is all beginning and ending.

It cannot be true joy.

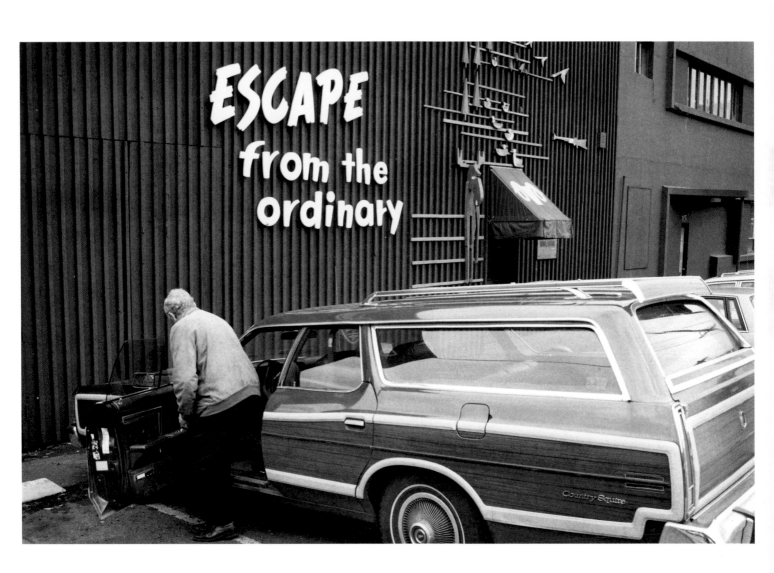

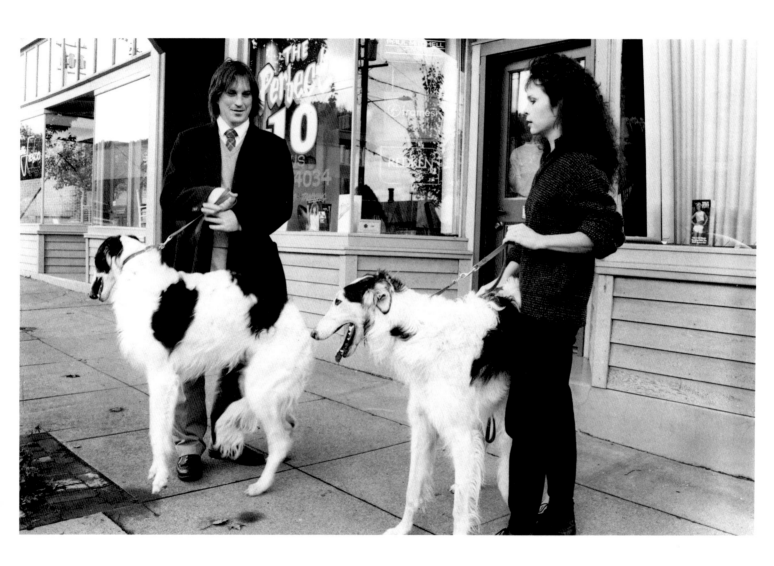

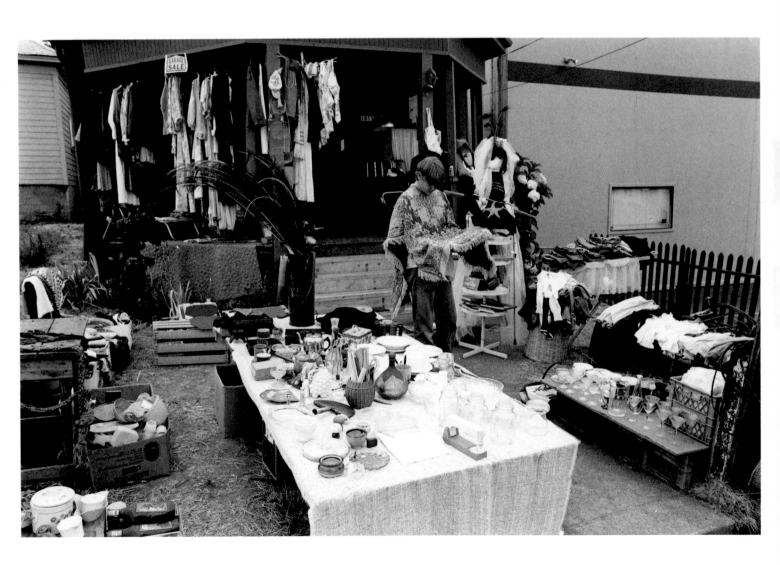

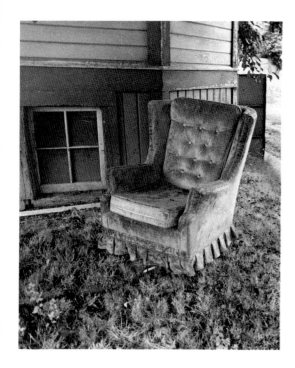

A house stands
in the same place but
takes its stairs off
throws a wing out
opens and shuts windows
rearranges organs
is repartitioned
as often as Poland...

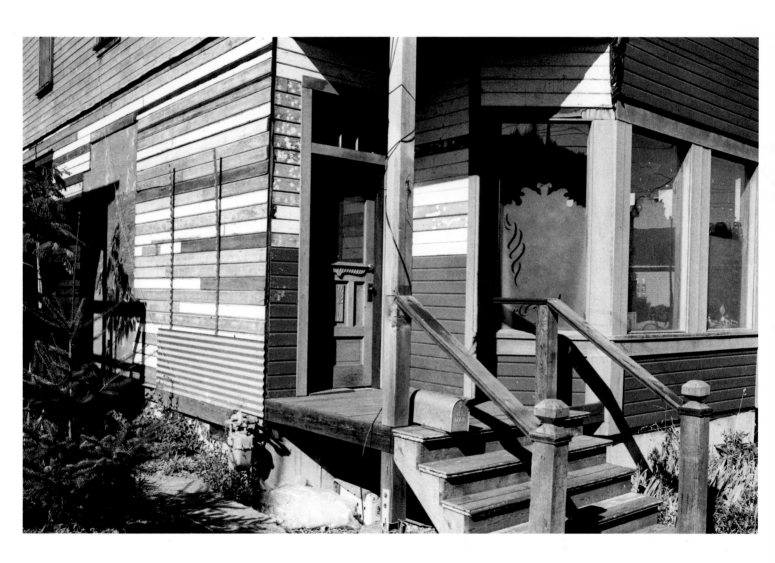

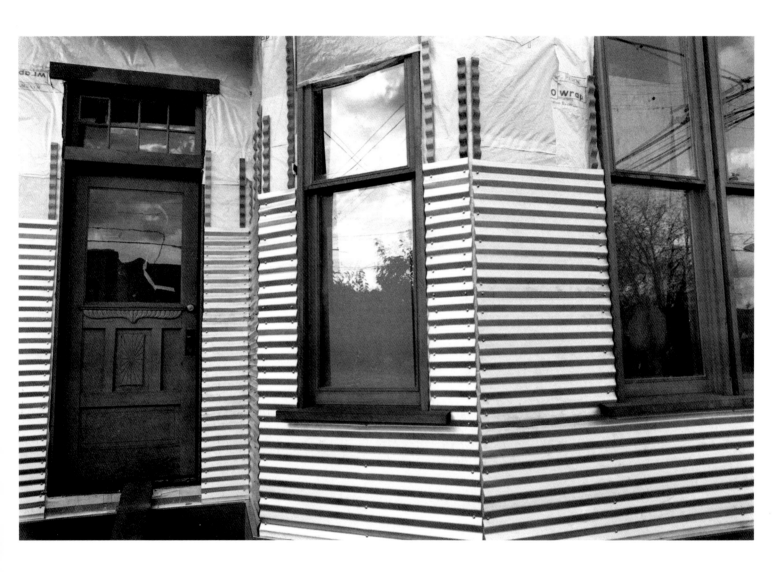

. . . A house sheds
its skin
sheds its inhabitants
eats children
spits out adults
till what the same house is
is a good question.

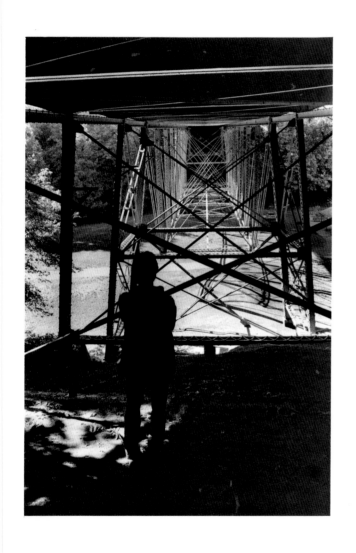

Thurman Street
crossing its bridge says:
I take off for a moment,
I leap!
I lay me down on trestles
to jump the gap
like a spark.
And the park starts
under my feet.

Busses jostle
the framework, the maples.
Swallows swoop under asphalt.

Where I hop the creek
it goes into hiding.

How many streets
get to cast a shadow?

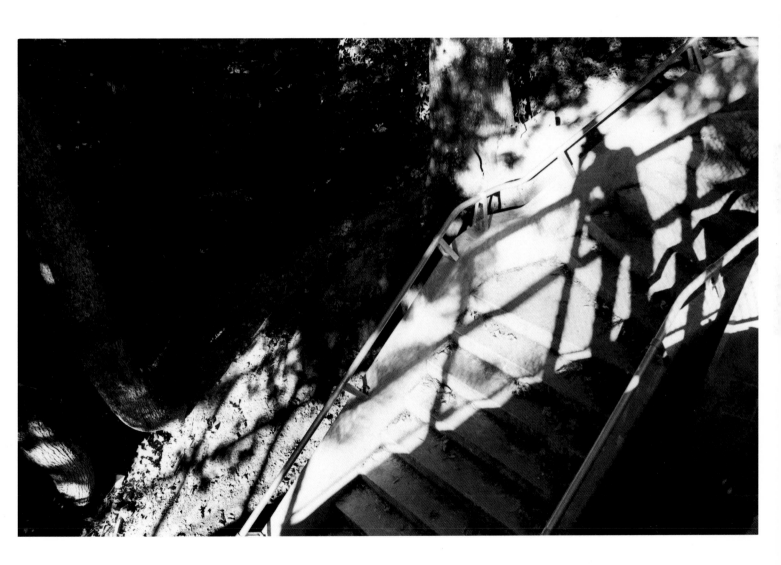

Even now
any path up here
goes sideways,
goes away.

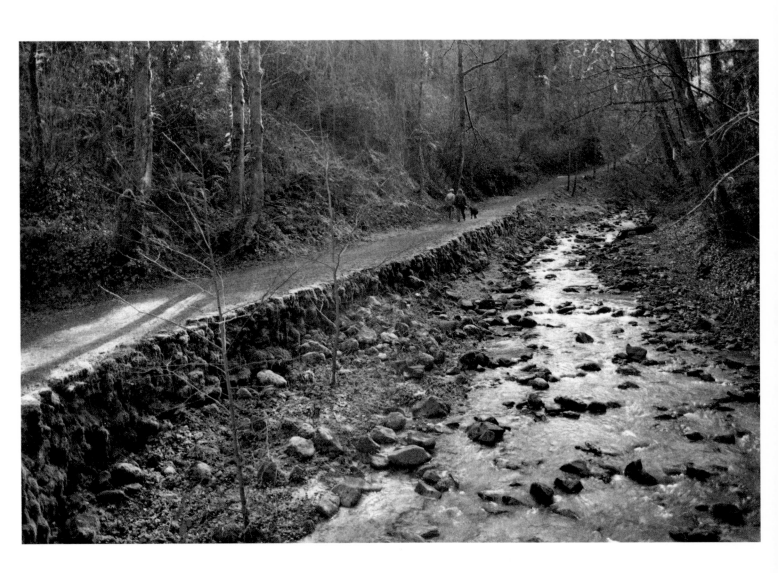

Before its birth all being is unseen,

after its death, unseen again.

All being is seen between

two unseens. Therefore why grieve?

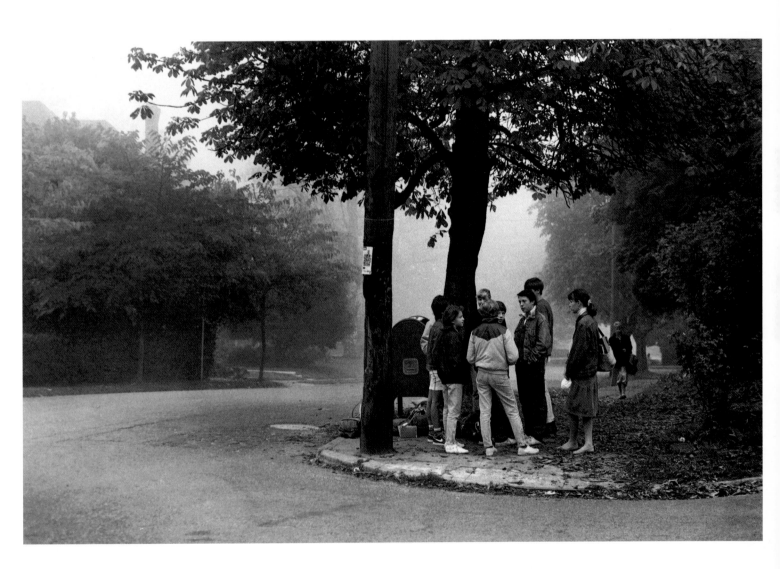

Housewife
Housewoman
Woman house
Lifeholder
Household
Stronghold

Doorway I call you
Door of the mystery
Woman I call you

Stronghold
Householder
Lifehold
Womanhouse
Housewoman
Housewife ⎯

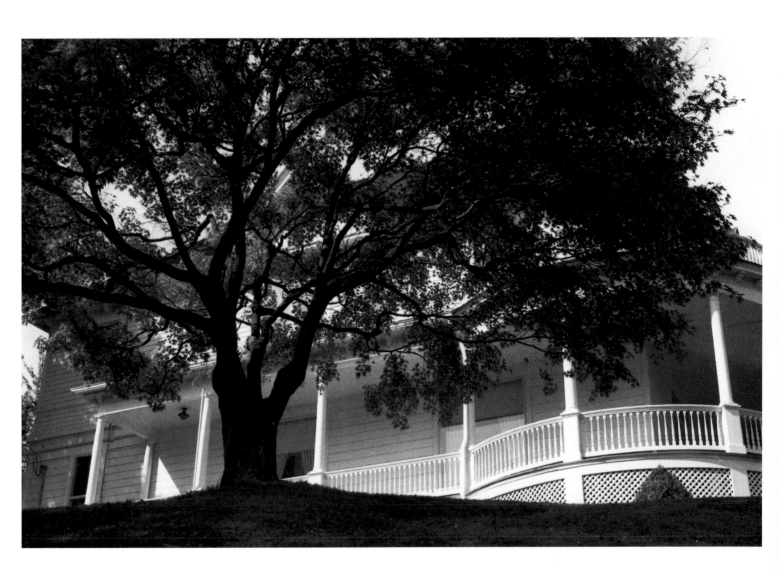

"Will you look at that?"
"Shoot. Look at that."
"Nineteen hundred?"
"No. Eighteen-ninety. Maybe earlier."
"What IS it?"

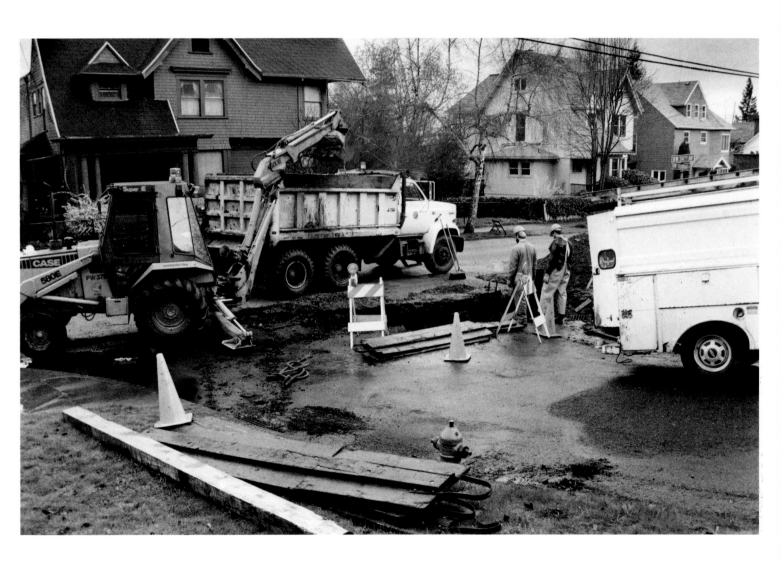

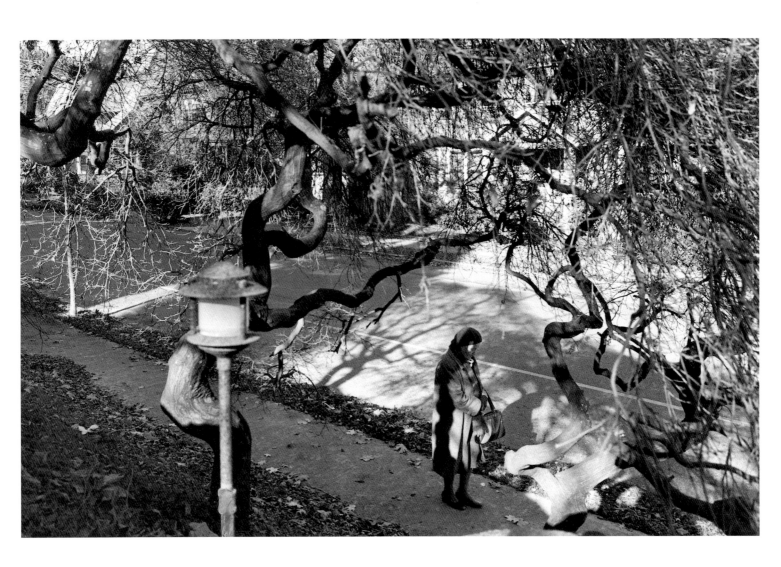

Bearghost shuffledances
in a dark time
on a dark pavement.

Maybe forest returns.
Maybe womanghost
softshoes under dark trees.

—Did you see that?

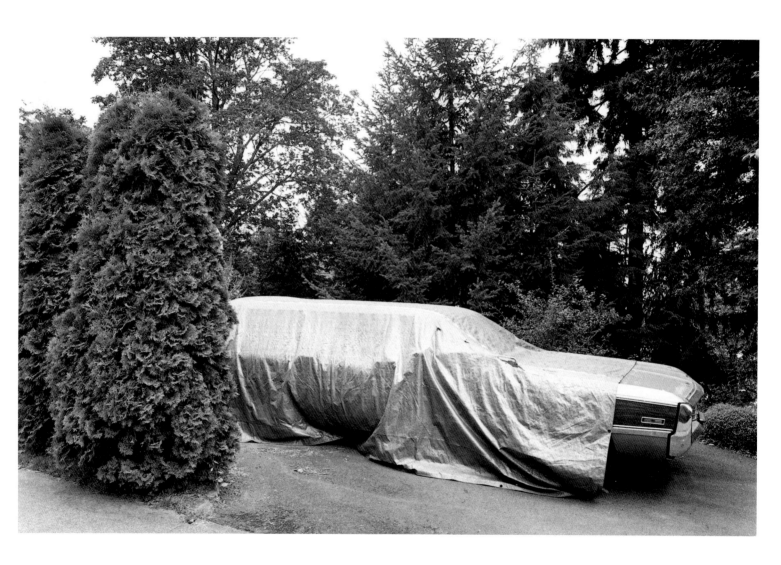

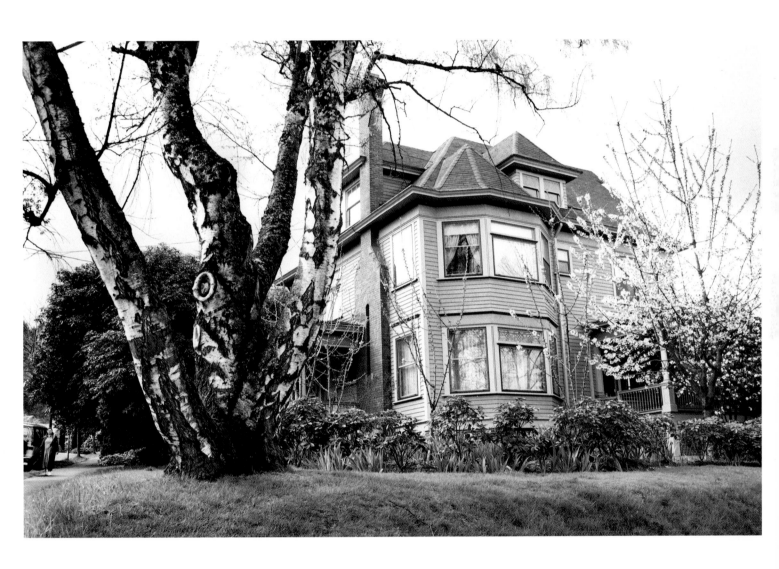

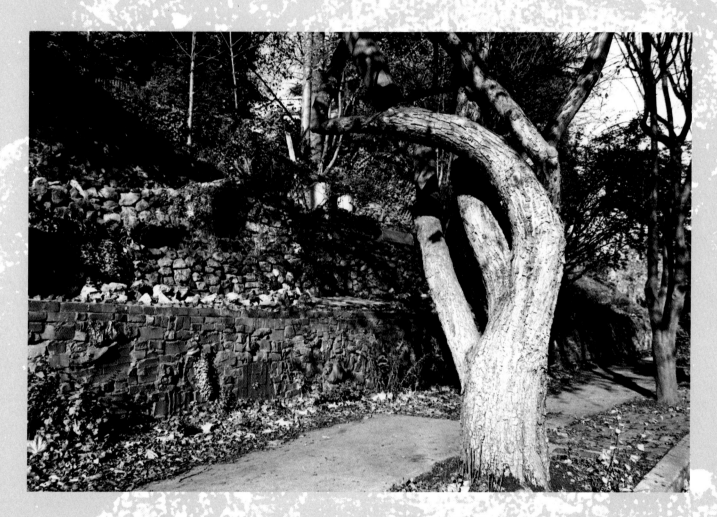

Beyond our understanding is the changing form

of that tree....

The Aching Air

Where the most beautiful
horsechestnut held up deep branches
in a cathedral
full of wings and voices
and a golden light,
and the tall, rose-white flowers
smelled like the bread of heaven,
and eyes praised up raised,
being blest by seeing:
where the tree was
the air's empty.

The insatiable vacuum
of a mean fear
in envy of that strength,
that lively age,
sucked there.
Destruction, the old man raged,
give me destruction!
And he got what he wanted.

Trees are so dirty,
the lady said.
The birds make the car
so dirty. All fall
I have to sweep the sidewalk.

Five fingers
has the chestnut hand,
loosely holding
candles, conkers,
sunlight, twilight,
and letting them fall.

They cut off the great branches
first, then sawed rounds
from the top down the trunk
to the stump. Can't let it fall.
So saw off the fingers,
then wrists and ankles,
then knees and elbows,
then hips and shoulders,
so that nobody
gets hurt.

Then poison the enormous
stump, that keeps on trying
to send up shoots.
Hack at the roots
and finally pull it
like a huge tooth.

The broken wood
was sweet and white.
People kept coming by,
slowing down in cars,
stopping walking, to stare.
Nothing there.

No fall,
all fall.
All clean.
All bare.
Only the tall,
tree-shaped, empty
aching air.

I have been born

many times, Arjuna,

and many times

have you been born.

But I remember, and you forget.

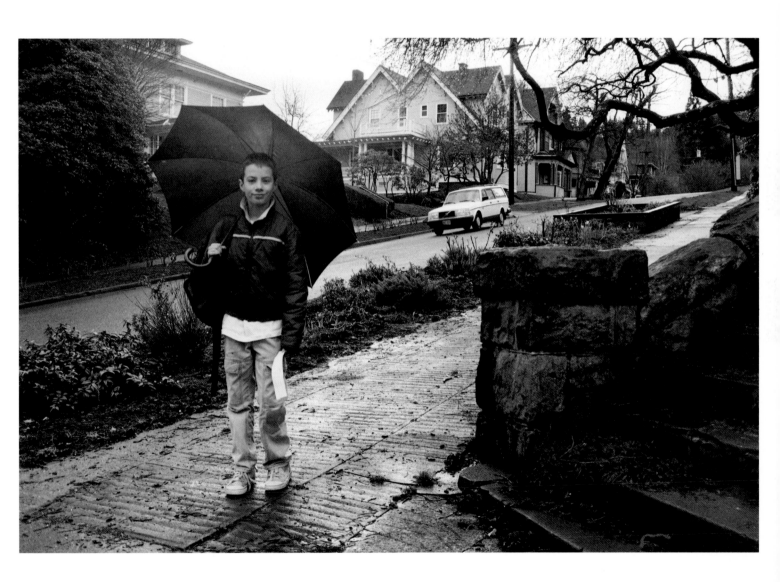

When I see your gentle

human face, my Lord,

I return into myself

and my heart is peaceful.

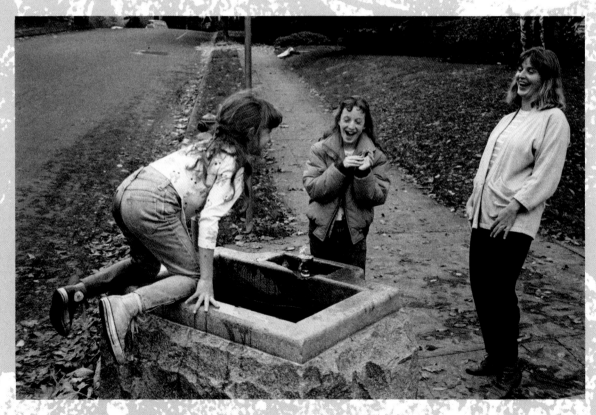

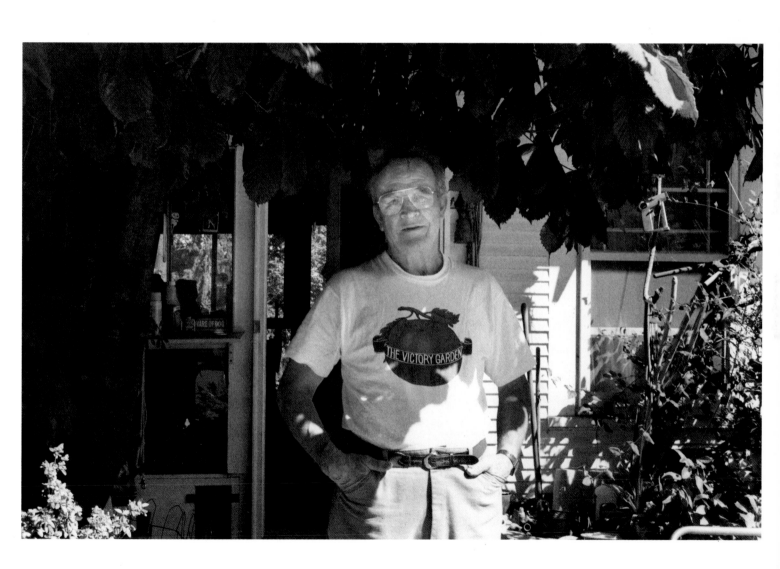

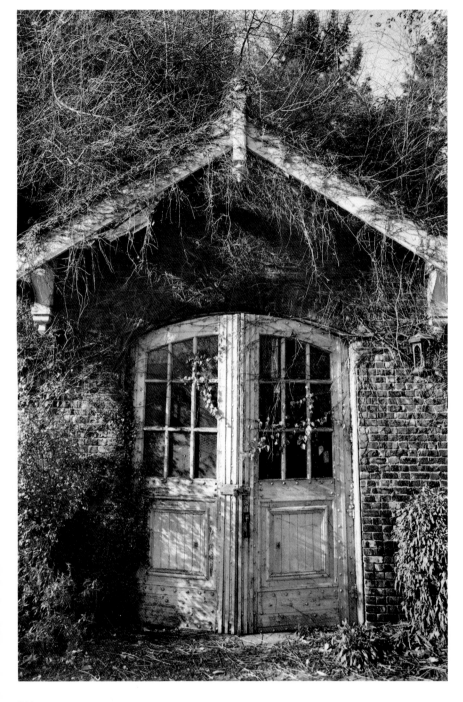

Ever more mysterious
grow the doorways,
even of garages.
Within
there is maybe
a Silver Shadow
that has taken
root.

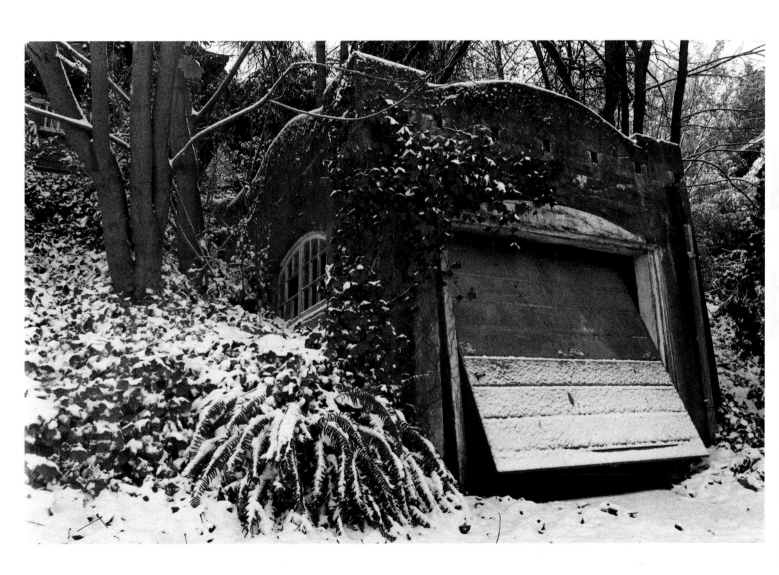

Souls take their own ways

sideways

Notes on the Photographs

These notes, written after the picture-taking was done, were gleaned from my journal entries and memories of conversations and things that happened. They provide the photographs with a matrix of time, location, and background for readers wanting additional information. And they allow us to tell another part of the story that Thurman Street told us.
— R.D.

I come into these notes in italics, now and then, to give my perspective on the scene. These notes also give the source of any texts accompanying the photographs that I did not write myself; they were told to me, or I overheard them, or they are from the Bhagavad Gita. *I arrived at a personal version of the* Gita *by making a sort of collage of various translations.*
— U.K.L.

The Photographs

Page 5

Young horse chestnut tree at 29th and Thurman. The text on the facing page is from the *Bhagavad Gita*, 15:3, and the background image is an Ajantā Cave painting from India.

Page 6

The colossal statue of Portlandia coming up the Willamette River by barge on August 9, 1985.

Page 7

A logging truck passing through town at Thurman and 22nd, 1987.

Page 8

Northwest neighborhood protest against property developers in 1990.

Page 9

At the Thurman Street Fountain, corner of 31st Avenue.

Page 11

On upper Thurman. Neighborhood dogs Ricci and Sheba.

Page 14

August 1985. Lower Thurman between Front and 14th Avenues.

It felt humbling to be on foot there in the shadow of the mighty Fremont Bridge. It was a good starting place, auspicious: the confluence of Portland's river, Front Avenue, the Southern Pacific Railroad tracks, and the airborne freeway. After about an hour I took this photograph, finding something of myself in the solitary traveler who happened to be passing through.

Page 16

September 1985. Thurman and 18th.

A modern-day ruin, this old warehouse ravaged by time reminded me of old stucco walls with flaking scales of paint I have seen in Mexico. It looked like this until 1990. Before that the only change I noticed in passing was the message on the billboard. It read like a changing epitaph: "Non-Stop Rock," and later, "It's About Time."

In the early 1990s the building was finally bulldozed, and a new building of the same scale was erected on the site. The high-end interior design outlet within has its landscaped entrance and sign on 18th Avenue facing Norm Thompson's exclusive outdoor apparel. Perhaps the idea is that you can outfit yourself and your house in one stop. The wall facing Thurman Street is uninterrupted raw concrete running the length of the lot: another gigantic tabula rasa for the grafitti artists who haunt the area. (*Or they might do what the Broadway Cab Company did (see page 23) and offer the wall for a mural competition!*) The billboard is still there. Today it says: "You've Just Found the Key."

Page 18

March 1987. Thurman and 15th. *The text is from the* Gita, *4:17.*

The man on the left is known as Red, or Yukon Sam. In the middle is Leon, also called Lucky. I was never able to get the name of the man on the right. At the time the photograph was taken they were camping several miles from here, under the St. Johns Bridge farther down river. Living the life they do, they say it's safer to band together, a triumvirate in this case. Lucky did all the talking and was obviously the "camp boss." He was friendly, genuinely interested in our project, and agreed for the threesome that they would take some time away from their rounds of collecting recyclable cans and bottles in order to pose for me.

Late in 1988 I was saddened to learn from Homer Medica, our grocer friend [see page 53], that Lucky had died of jaundice. "You know, that's what gets a lot of them," Homer said. "Liver. He came in here one day and was yellow as a lemon. I told him he'd better get to the hospital. I guess he did, but I saw him in here again a couple of days later in about the same shape. He said he was going to rest for a week. I guess he just laid there in his sleeping bag under the bridge and died. That's the way they are. They don't take care of themselves. He was a real nice guy. I liked talking to him. He used to come in here all the time, and we'd talk."

It's possible, however, that Homer meant a different man, because I have also heard that Lucky's name was really Leon, and that he is all right. Red is said to be living under the Fremont Bridge with a new partner. I saw him on 23rd Avenue in January of 1993. I never learned the name of the third man and have been told that he went south, that nobody knows where he is, and that he may be dead.

Page 21

September 1988. Between 16th and 17th on Thurman. *The text is from the Gita, 4:16.*

Rose City Antique Car Emporium had a small sandwich-board sign out front that read, "Used Tire Sale — five dollars and up." Samples were frequently strewn along the sidewalk. These men were unloading a rack, which may be for tire storage. I had rarely seen any activity on this block, so I was delighted with the opportunity to photograph the event.

Page 22

December 1986. Lower Thurman.

Another freeway casualty being towed.

Page 23

June 1987. Thurman and 15th.

In early 1987 the Broadway Cab Company offered the blank north wall of their building, plus materials, to the Pacific Northwest College of Art in the hope that students might do a mural there. A design competition was held at the school, and the mural did come to pass. It is a lively addition to the industrial drabness of the area, particularly as seen from Front Avenue. Broadway Cab has hung a neon sign on the mural, but the graffiti artists have respected it, leaving it unscathed, so far.

I took many photographs of each phase of the mural project

during the weeks it took to complete. The woman atop the scaffold was the winner of the competition; her name appears in the lower right corner of the mural: Coralee, 1987.

Page 25

September 1986. Between 16th and 17th on Thurman.

This is Rose City Antique Car Emporium's side yard, a bone pile of old cars and parts. The cow's skull on the wall contributes a surreal element to this purgatory for yesterday's heroes of the highway, which stare forlornly through empty headlight sockets, waiting to be reborn.

As I positioned myself to photograph this captivating scene, an ancient guard dog emerged from the back seat of an Oldsmobile.

The opening celebration for the mural

His loud baritone bark was measured and seemed more routine than mean. He ambled arthritically toward the gate, barking, until he reached my extended hand. A quick sniff convinced him I was harmless, or perhaps uninteresting. He positioned himself cooperatively at the gate, completing the picture.

Page 26

January 1986. Thurman and 22nd.

Before the entrance to I-5 was changed, drastically reducing traffic flow on lower Thurman, I took this photograph and made the following journal entry: "From 22nd Avenue to the freeway on-ramp is a veritable launching pad during the early morning. As a pedestrian I felt assaulted by the incredible din and turbulence. Hundreds of gallons of gasoline are sucked up there and belched back in a toxic breath by overburdened engines forced to run wide open under mindless stomping to the floorboards. When the light turns green, gas pedals flatten, tires squeal struggling to keep up with the drivers who are already way beyond, halfway to work, freeway in their veins, still on Thurman Street."

Page 28

July 1986. On lower Thurman.

Traffic arrows, when Thurman was an on-ramp for the freeway.
Below 15th the street now runs one way, uphill; and in order to get to lower Thurman from upper Thurman you have to take a strange little

detour road that veers off from the freeway entrance on 23rd and Vaughn. People who mistake this road for the freeway drive around in circles until they learn how to escape. It seems ironic, as they drive past Norm Thompson's — "Escape from the Ordinary!"

Page 29

July 1987. Thurman and 23rd.

It was a warm morning of early summer, and there was little traffic. The young woman holding the stop sign seemed lost in a daydream. I decided to use my 28mm lens to include her in the shot without disturbing her reverie. The 28mm lens is less confrontive because you don't have to point directly at a subject to include it. I appeared to be just photographing the barrier.

Page 31

June 1986. Thurman and 24th.

By coincidence, or maybe intuition, Ursula broached the idea of collaborating on a book about Thurman Street on the day of a blue moon — the second full moon in the month of July, 1985. As the idea began to take form, it became in my mind the Blue Moon Project. That epithet set a tone, rang true, and eventually found its way into our title. Obviously there had to be at least one full moon in the book.

The photograph also has one of the two glimpses of the old Beaver Cafe, a landmark restaurant and bar on the north side of the street. The polka-dotted tile around the front door and the tacky neon sign featuring the establishment's totem animal gave the place an aura of the fifties, which I suppose was its heyday. I can imagine working men from the industrial district to the north of Thurman stopping there on Friday nights to cash paychecks and drink ritual beers in celebration of the end of another hard week.

Food Front Cooperative Grocery replaced the Beaver Cafe, and now that the cafe is gone I get a feeling of nostalgia when I look at this picture.

When I look at this picture, I want to sing the blues. I don't know who he's trying to call, but I know she isn't home, or isn't going to answer. Not in a blue moon.

Before the Beaver was the Beaver, it was a Safeway store, the first in Northwest Portland. Safeway moved their store over a block to Vaughn Street, and then out of the neighborhood. Food Front began in a tiny hole-in-the-wall shop on 23rd, moved over onto Thurman, and started growing. With its high-quality goods and strong sense of neighborhood responsibility, the co-op has been for many years now a center

of vitality for the whole district. It is an example of genuine sixties idealism flourishing and nourishing through changing times.

This little photograph of the Food Front entrance shows their map of the Forest Park trails; around the corner on the east wall is a marvelous mural of the forest itself by Lynn Takada, painted with the help of nineteen children, ages 8 to 13. The mural was sponsored by the Portland Audubon Society, Pacific Northwest College of Art, and Food Front, and was completed July, 1991.

Page 32

August 1985. Thurman and 23rd.

During the early months of our project much of my shooting was done on weekends. The absence of traffic and noise gave me the opportunity to concentrate on the buildings and to familiarize myself with the setting. At first Thurman Street looked bereft of engaging

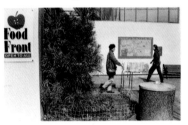

Food Front Cooperative Grocery.

subject matter. It lacked the urban density I like to photograph and seemed to have very few buildings that were interesting in their own right. On this particular Sunday afternoon I couldn't get excited about anything I saw, and it was terribly hot.

I heard myself muttering, "This is not going to be easy," a thought that I tried to counter in my better moments by telling myself to keep looking. In this case I settled for long shadows and a lonesome mood.

Page 33

August 1986. Thurman and 17th.

I had been holding this corner in reserve, knowing I could always get some good "people shots" in front of the Pyramid Club, particularly after dark when spiked hair and nose rings became the norm. With the streetlight overhead and the open door providing backlight, I might capture the silhouette of a mohawk or catch the flash of studded leather. On this particular evening I had gone to the Pyramid Club because a poetry reading was scheduled there in connection with the annual Portland Poetry Festival. I was looking forward to the collision of punk hipsters and self-conscious literary types, the kind who wear leather only in patches on the elbows of their corduroy jackets. But it didn't happen. There were more poets

than there were listeners, and I came away with this picture of a quiet night at the Pyramid Club.

The club closed after just six months; it was rumored that increasingly burdensome insurance rates brought it down. The building stood vacant for years, but during the winter of 1992-93 it was given a facelift, a make-over. It seems to be looking for a day job now, dressed for business, with For Lease signs in its eyes.

Page 34

April 1987. Thurman and 16th.

It was Saturday afternoon, and it had just stopped raining. The reprieve from the leaden grey skies, however brief, charged me with anticipation. For a few minutes celestial light flooded the street, bathing the buildings in the general glow. I hurried to photograph the facades of Rose City Classic Car Emporium and the building next door. Both have an architectural style reminiscent of early Western towns. Nestled under the freeway arteries and across the street from the broad shoulders of the Lutz Tire buildings, the Emporium looks somewhat quaint. I see these older buildings as a fragile part of the environment, like endangered species that may not be there the next time you look.

Page 35

March 1987. Between 24th and 25th.

The photographic story of a street in Portland, Oregon, would tell a lie if it didn't have a couple of pictures taken in the rain. On this occasion the cab of my van provided me with a protective canopy. I stopped because the door to Action Machinery was open for a change. I had rarely caught a glimpse of any action there. My wide angle allowed me to include the old Ideal Theater, a warehouse for a long while. It is currently the studio of two of Portland's finest photographers, who own the building and rent out the small southeast corner to Maya Evans's shop of imported jewelry, clothes, and art. The owners have done some tasteful redecorating on the front of the old theater but have left the side of the building alone. In this photo you can see the faded Multnomah Battery sign on one flank, and on the opposite flank, hand painted on the irregular brick surface in "oriental" script, is the Ideal Theater logo, with its hours listed below. It's a beautiful example of the endangered craft of sign painting. The painter, obviously proud of his work and no doubt looking for more, put his name at the bottom.

Page 36

October 1985. Thurman and 23rd.

This is one of Thurman Street's busiest intersections at rush hour on a Friday afternoon. As these women passed me, the one in the middle of the picture approached me sternly and asked if she was in my photograph. She looked fully capable of using her umbrella to give me a good whacking, so I told her I was photographing the traffic and buildings. To my relief she grinned at me, feigning disappointment: "Darn!" she said. I hope that she'll forgive my half-truth and that she's happy now to see she really was in the picture.

Page 38

July 1987. Thurman and 26th.

"Play it! Watch it! Win it!" This triple imperative touches several major preoccupations of our society.

I took many photographs of this storefront because the mini-market is such a ubiquitous presence throughout the country, and this is the only one on Thurman Street.

When my children were in Chapman Elementary School, a couple of blocks from this intersection, the Quik-Mart was a nice little place; we bought candy and MAD magazines there. But like so many 7-Elevens, it seemed to collect trouble, and I stopped going there when it posted a sign: "Only Two Children at One Time in Store." I suppose some of the kids were horsing around, maybe being troublesome; but given the quality of some of the adults who hung around there, I couldn't see why they picked on the ten-year-olds.

Page 40

1989. Thurman and 23rd.

I see the postered telephone poles around the city as distant cousins to the totem pole. The color and collages formed on them enliven an otherwise visually drab environment.

What fascinates me, aside from the incredibly involuted names of the rock groups in the posters, is the incredible determination of the city to waste money in ripping, tearing, and burning the posters off the poles. They actually go around with a sort of flame-thrower, attacking feral posters. It does leave wonderful surrealistic effects behind on the poles.

Page 41

June 1987. Thurman and 26th.

This shot was taken around noon on a Saturday at the bus stop in front of the minimart. This intersection was a photographic power

point for me. Six of the pictures in the book were made within a radius of fifty feet from here.

Page 43

August 1986. Thurman and 26th. *The text is a story told us by Patricia Miers.*

This is the same bus stop as on page 41, about a year earlier. Again three people and a sunny day, but a completely different mood.

Pat Miers was the proprietor of the Thurman Street Bookseller at the intersection of 24th. For a glimpse of her shop see page 47. When she told us this tale of the woman with the butcher knife, she was already planning, regretfully, to close the shop and move to the suburbs. She said she could stand the exciting life on Thurman, but a secondhand bookstore's proceeds wouldn't pay the constantly increasing rent.

Page 44

July 1988. Thurman and 28th. *The text is Pat Mier's story continued.*

This is the entry to the Crackerjack Tavern. Passing, I was startled by the human-sized wolf at the door. There was something eerie about it that held my attention. As I framed the wolf in my camera I was pleased it fit into the geometry of the open door.

I have heard that for a while the wolf stood outside on the sidewalk with a plastic woman companion. The pair were offensive to some neighbors, so the tavern moved them inside.

I didn't say anything about it, but they were offensive. The Crackerjack serves a mean hamburger, by the way.

Page 46

September 1987. Thurman and 26th. *The text is from the Gita, 2:9 and 2:10.*

This apparent nonconfrontation is a rare one in Northwest Portland, which is still very predominantly a white, Anglo district, suffering from racial monotony.

Page 47

August 1987. Thurman and 24th.

This photograph shows the front window and entry of the Thurman Street Bookseller shortly before its doors closed for the last time. I'm sure the irony of the juxtaposed appeals by Paramahamsa Yogananda and Uncle Sam was not wasted on Pat Miers. The photograph would have been quite different if the gentleman about to cross Thurman Street had not appeared.

This is where the woman with the butcher knife made Pat crawl under the table with the records and the gourmet magazines. Currently the shop is occupied by Caffe Fresco, a charming and lively addition to the street scene, though many of us wish we could have kept Pat and her books, too.

Page 48

August 1989. Just off Thurman, under freeway overpass.

These homeless men [bottom photo] were working hard on a Sunday afternoon, stripping wire that they had found in drop boxes. They salvaged the copper, which they were selling by the pound to metal recyclers. At first they were suspicious and reluctant to be photographed, but they became interested in our project as I talked with them. I was impressed by their awareness of city politics, particularly issues that touched their lives directly. They had hopes that the photograph might help make the public more aware that the homeless "aren't just a bunch of bums who don't want to work."

Nearby was another camp, whose occupants declined to be photographed. Their camp was quite elaborate, complete with tables, mattresses, crates for food and cooking pots and pans. There was a fifty-gallon metal drum with a grid on top for cooking. Everything except hot and cold running water and electricity. Behind the camp was a wire fence hung with a lot of used clothing. The camp boss told me that they sold enough clothing to make a meager living. "And you'd be surprised who some of our customers are," he said. "There's a minister and a retired cop, among others." He claimed that life under the bridge was less violent than around the food kitchens and shelters downtown. Their only problem was with the cops who kept threatening to kick them out but hadn't yet followed through. Consolidated Freightways owned the property they were on and permitted them to stay there in exchange for watchdogging their yard. "They've been real good to us," he said.

Since the construction of the new freeway overpass and the severing of lower Thurman, the area these men were in has been fenced off. No doubt they've moved on, perhaps over to the east-side freeways. It's hard to imagine what moving day must have looked like.

Page 48

September 1988. Thurman and 25th. *The text is from the Gita, 4:18.*

One of the "good old houses" of Thurman Street, with its lovely border of roses and its inhabitant with her beautiful, kind face. Although she was slightly embarrassed when I asked to photograph

her, she didn't say no, and I went ahead. I couldn't resist this view, which is so typical of Northwest Portland.

Page 49

April 1986. Thurman and 27th.

This house and yard look pretty much the same now, in 1993, as when I took the photograph. The man in the picture is the owner of the property, which he rents out. When I approached he paused from his labor, and we talked for a while. He told me he had been finding a lot of old marbles as he dug up the front yard. I was reminded of my own marble-playing days and the close contact with the earth that children seem to relish.

After I explained our project, he began telling me what he knew about the neighborhood, interjecting some of his own personal history. As a young man he had been employed at Montgomery Ward (now Montgomery Park International Trade Center), an architectural landmark in its day, and still the biggest building in Northwest Portland, standing a couple of blocks north of this intersection. He worked on one of the upper stories as a file clerk. Because the area they had to cover was so vast, the clerks performed their duties on roller skates. I sometimes find solace in the abiding vision this story has given me. I imagine dozens of neatly uniformed young men floating on their skates to organ music around acres of file cabinets, a world where drudgery has been transformed into delightful, harmonious play.

Page 50

July 1986. Thurman between 24th Place and 25th Avenue. *The text includes a line from the* Gita, 2:28.

It was the first time I had seen the big sliding doors to Action Machinery left open. I clicked the shutter just before the man approaching asked sternly what I was doing. Describing our project, I assured him that I had no ulterior motive, and he softened. He let me have a brief look at what they were doing inside but would allow no photographs. His orders were to maintain security. He explained that the metallic monsters that had just been spray-painted with primary colors were state-of-the-art robots used in foundries, whose design and engineering features they didn't want to fall into the hands of competitors. I left with the feeling that Thurman Street had just given me a glimpse into one of its secret worlds.

Nowadays the sign on the building reads, "Compacting Technologies Inc." The name is completely confounding to me. Does it have something to do with recycling, or with reducing the scale of existing technologies? It remains a mystery, behind those sliding doors that continue to remain closed.

Every now and then I get a glimpse in, on the way to Food Front, but have no idea what they compact in there. So much of what we do, in houses or in warehouses, is a mystery to others; we no longer understand one another's work.

Page 51

July 1988. Thurman and 24th.

This split image shows the interior of Schmeer Metal Works and a long view down the sidewalk heading west on Thurman.

Some months earlier I had had an encounter with the owner in front of his establishment. I was attracted by the pattern of sheet-metal scraps leaning against the inside of the front window and stopped to take a photograph. As I positioned myself, an elderly man got out of a pickup truck, approached me, and asked what I was doing. I explained our project, but he seemed baffled by my interest in photographing the mess in the window. He assured me that the scraps weren't there for decoration. "We work hard, and those just landed there. I've been here for forty years. That's my name up there," he said, pointing to the sign overhead.

He told me that the building had been occupied by another sheet-metal business before his. The other fellow went bankrupt and prophesied the same fate for Mr. Schmeer. After telling me this he reiterated, with justified pride, that he'd been there for over forty years.

The building housing the metal works was added on to the adjacent structure (now Uncommon Threads, a yarn and weaving shop), which housed the Beaver Cafe before the Beaver moved across the street into the old Safeway building. The facade is comprised of square glass tiles glued to the surface. The materials and technique are unusual and apparently no longer used, which gives the modest building an interest of its own. (*And probably makes it impossible to replace or repair tiles lost to accident or vandalism. I never looked at this facade until Roger told me about the tiles, and now I always admire it, and worry about damage to it. A little knowledge is a dangerous thing!*)

The next thirteen photographs are portraits. These faces tell their own stories. I thank them, and wish only to add a few words to some of them from what little I know about these people.

The first months Roger photographed on Thurman, most of his images were of buildings, cars, lots, almost inhuman vistas. He was seeing

a lonesome, bleak street. My Thurman seemed to be livelier, with a lot more people living and walking and going about their business on it, and I asked Roger if he would make more "people shots" in order to catch this aspect. The result was this lovely series of portraits. I felt that, other than their own words in a few cases, any accompanying text would be impertinent.

Page 52

September 1988. Mrs. Rose Medica talking to a friend in front of the family store. *The text is from a conversation with Homer Medica in 1987; we had asked him what Thurman Street was like during the Second World War.*

Mrs. Medica (who is the woman on the right) moved here from Austria with her husband in 1935, when she was twenty-one. A clear-eyed, direct woman with a no-nonsense manner, she is still working in the store.

Page 53

January 1987. Mrs. Medica's son, Homer, in the doorway of his store, the Twenty-third Avenue Market.

Homer has lived and worked on Thurman Street for over fifty years; he was born in an apartment just down the street from his grocery store. He is very knowledgeable about the neighborhood both past and present.

The Twenty-third Avenue Market is a high-quality little store with a good meat market, a rarity these days. Homer Medica doesn't have the confrontational attitude to street people and the homeless that so many small-business proprietors have; he is unprejudiced and unafraid, cool with a tough customer and courteous to anyone who shows friendliness.

Page 54

July 1987. Thurman and 23rd Place.

This is a portrait of old Joe. For years he could be seen almost any day walking in the neighborhood or sitting on his friend Henry's front porch, where this photograph was taken. The two of them spent hours there talking, watching a TV set they balanced on the porch rail, or just sitting, watching the flow of life on the street. I don't know much about Joe except that he had lived in the neighborhood a long while and was once the night man at the Beaver Cafe. That's their logo pin on the front of his cap. During his final days on the street Joe walked with measured steps, using a cane. He seemed determined to keep moving, and I think that's what kept him alive. I used to see him so often I thought of him as Mr. Thurman Street. Several

years ago Joe's health declined, and he had to move downtown to the Taft Hotel retirement home. Henry recently told me that Joe is dead.

Page 55

July 1987. Thurman and 23rd Place.

Henry has lived in the Portland area all his life. The house in this picture is one he had rented for fifteen years. He was worried that his landlady might sell it to cash in on the heavy development taking place. He told me that if he was evicted, he had a sister in Newberg he could stay with, but that her place was rural and isolated. "I'd miss the people around here," he told me. "I know a lot of people around here."

Henry's fears came to pass: the house was sold to a developer.

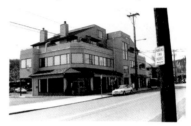

The site of Henry's former home.

But Henry has managed to stay in the neighborhood, thanks to Homer Medica, who rented him one of the small apartments above the Twenty-third Avenue Market and made him the manager. I frequently see him sweeping the store entry in the early morning and late evening. Henry is at least eighty now and still has his smile.

Henry's former home was replaced by an austere, multiuse structure that seems out of place to me, even though elements of its architectural design relate to nearby buildings. The ground floor currently has a dry cleaner, a print shop, and a restaurant, which is already in its third incarnation. Danny's European Cafe was gone almost before it came, and Harmony in Red ended on a sour note in less than a year. I had cake and coffee there one afternoon and was surprised to be waited on by a young man wearing a tailored white jacket and black slacks. It didn't seem like our Thurman Street.

The current restaurant, Singapores, plural, hasn't died yet. Twenty-third Avenue has become a very good restaurant area, with several excellent places a few blocks from Thurman. Used to be there wasn't anything but the Quality Pie shop. We got two, not one but two, fried flies in a hamburger there once. But the "QP" too is closed now, lamented by many.

Page 56

August 1987. Thurman and 23rd. .

These three obviously know each other well. They live along Thurman on the same block as Homer's grocery.

Page 57

August 1987. Between 27th and 28th on Thurman.

This was the Food Front Co-op building before it had to move to larger quarters down the street. The bench in front of it was always occupied by somebody, usually several somebodies. I love this photograph, which I call "The Love Letter."

Page 58

February 1988. Thurman and 26th.

These two men were just finishing their lunch break when I asked them to pose. The decals on their helmets indicate long years of employment with Esco Corporation, a block north. Esco is a steel foundry that manufactures parts for earth-moving equipment such as bulldozers and scoops for open-pit mining. The company has been in the neighborhood for eighty years and is still run by the grandson of its founder.

There's a fine statue of a workman on the Esco grounds. Once, trying to photograph it reflected in the glass doors of the building, I was pounced upon by security guards as an industrial spy. I was terrified, though flattered. Since then I have left the industrial photographing to Roger.

Page 59

July 1987. Thurman and 28th.

These four fellows had just clocked out for lunch. At the time they were all employees of Faulkner's, where generators, alternators, and starters have been built since 1926. A year later, the man on the left was still working there, but the others had moved on. The man on the right was a shift manager at a McDonald's in the industrial district, and I wasn't able to get information on the other two. The motto over the door at Faulkner's reads, "Consistently the Best." There was something about that sign and these all-American faces that was very moving to me.

Page 60

July 1988. Between 27th and 28th.

This kindly and wise-looking man had just returned from a trip to Montana. I thought he looked great and told him so, and he agreed to pose. He lives several blocks up Thurman from the brick apartment house where he is standing.

Page 61

August 1987. Thurman and 25th.

This woman had waited on me many times over the years at Quality Pie, a few blocks away. Because of that familiarity I felt emboldened to ask if I could take her picture. Obviously there was no water shortage that summer.

This is another of my favorites; I think of it as "Generosity."

Page 62

June 1987. Thurman and 25th.

The text is word for word what I heard a teenager say to her friend on the bus coming up Thurman one afternoon.

Page 63

May 1990. Between 24th and 25th on Thurman.

Pages 64 and 65

July 1988. Thurman and 26th.

These boys were more than willing to "stunt" in front of the camera.

Page 66

July 1986. Thurman and 25th. *Some of the text repeats lines from Homer Medica's story.*

Old walls tell their story, too. I find them more interesting than freshly painted ones. Often they are richer in color, texture, and composition than many contemporary paintings. When I saw this wall, the west side of the Thurman Street Building, I ran to get my camera. Workers had scraped off the loose paint in preparation for repainting. In the process they had temporarily revealed some of the building's past. As you can see, the building was a bakery at one time; it has also been a grocery store and a cafe. As of 1993, Uncommon Threads shares the building with Franklin Printing.

While I was photographing the wall, one of the carpenters on the renovation told me that during the Great Depression people lined up clear down the block from Savier Street in order to get bread from the bakery. The carpenter had learned this from "an old guy around here who'll tell you all about it."

Page 69

September 1989. Thurman and 28th.

I stared into the viewer, through the lens, into and through the photographer's studio to the street beyond. My studio was Thurman Street in all its multiplicity. I became intrigued with the idea of making a single image that would read like a double, triple, even quadruple exposure.

The photographer has since moved her studio, and the building is now occupied by an architecture firm.

Page 70

November 1988. Thurman and 23rd.

This is Thurman Street's architectural "black tie," the home of Harris Wine Cellars, a wine shop and restaurant. The look of the building, the dampness in the air, and the quality of the light gave me the feeling I was in London. Looking at the photograph now, I can hear the proper English being spoken by the couple about to go inside for a bit of lunch.

Page 73

August 1987. Between 27th and 28th on Thurman.

It was a dog day in August, a Sunday — hot, muggy, nothing moving. I felt like a somnambulist with a camera. Passing the Community Gardens I heard voices and laughter. In the deep shadows under the horse chestnut, half-hidden by corn stalks and tomato plants, were people. In my excitement at discovering life on Thurman Street I walked right into the middle of their party.

"Gonna take our picture?" someone said.

"Sure," I said, "that's my job."

They were the gardeners, a merry lot gathered together to celebrate the bounty of their labor with an afternoon of picnicking, talking, and playing cards. The woman who served as their liaison with the City of Portland, sponsor of the Community Garden Project, immediately struck a bargain with me. I could photograph as freely as I pleased, provided I sent them some prints. It was a deal. I spent a very pleasant and relaxed hour in their company.

I am sad to say that the gardens are gone now, sacrificed to another kind of growth. I don't know the politics or rites of ownership involved, but the magnificent

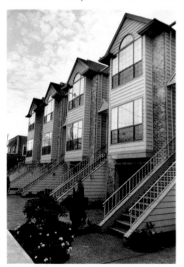

Row houses where the gardens were.

horse chestnut was cut down, the garden plots were bulldozed, and row houses — the hundred-thousand-dollar kind — were very rapidly erected. Now as I walk by their anonymous facades I think about the fertile ground lying under their foundations.

Page 74

July 1990. Between 23rd and 24th on Thurman.

Page 75

June 1988. Thurman and 25th.

After the row houses sprang up in the Community Gardens, there were only three empty lots left on the street. Then this one was bulldozed. No doubt the big steel blade tore into the Being that the Indians call our Sacred Mother without a single prayer or offering.

I'm glad I photographed the weeds in their prime.

When my kids were little, in the stroller or stumping along, we took lots of walks down Thurman, and this was one of the places we'd stop to pick daisies and dandelions and beautiful feathery wild grasses. To children an empty lot is a garden, a playground, a wilderness, a freedom. Though American cities, especially in the West, may look kind of messy and half-built because of their empty lots, it's just that easy, weedy freedom that makes them livable and gives them their own beauty.

Page 76

September 1987. Between 28th and 29th on Thurman.

From this point on up to where Thurman Street disappears into the forest, trees and shrubs are constantly threatening to take it over. Homeowners must whack away at them regularly to stem the tide. In anticipation, I took this "before" photograph as part of my documentation of the battle. Some months later the residents of this house, apparently unable to find their pruning shears, decided to use the ax. Instead of being shaped and reduced, the two shrubs were chopped off at ground level. The modest house, formerly almost hidden by them, now stands unprotected. Let's hope the cat escaped.

Maybe it's because things grow so easily in the Pacific Northwest that people think we can keep clear-cutting forever and still have trees for the loggers to log forever? Maybe that's what the cat's thinking about?

Page 78

May 1987. Between 27th and 28th on Thurman.

The wheelbarrow full of items gave me a chuckle, so I decided

to photograph this garage sale. The two women were sharing an apartment, and it was their stuff that was for sale.

Page 79

November 1986. Between 18th and 19th on Thurman. *The text is from the Gita, 5:22.*

This is the famous Norm Thompson store, whose ads are the reason Thurman Street appears regularly in The New Yorker. *The store is on lower Thurman and out of place in these pictures of the middle part of the street, but it seemed definitely to belong in this group of four photographs about consumers and consumer goods.*

Page 80

May 1990. Near the corner of 24th Place and Thurman.

This attractive couple and their beautiful dogs agreed to stop and allow me to photograph them. It seemed appropriate that we were in front of The Perfect 10, a beauty salon. (*Caffe Fresco, with stacked chairs, is visible at the left.*)

Page 81

June 1987. Thurman and 25th.

"Life is a garage sale. One man's junk is another man's treasure." The young fellow in the photograph was full of aphorisms. He had created a way of life, even a cosmology of sorts, from his collecting and reselling. "The trick is never to get attached," he said.

He put on the shawl he was pricing, for the sake of the photograph. During our conversation it never became clear if he did anything else for a living. There were a number of his original drawings and paintings for sale, which showed considerable talent, so I surmised he was an aspiring artist. When I asked him what he wanted to do with his life, all he replied was, "Heal the planet."

Page 82

August 1988. Between 24th and 25th.

Pages 83 and 84

August 1986 and January 1987. Thurman and 26th.

Page 85

January 1987. Thurman and 26th.

You might not realize it at first, but these three pictures are of the same house. A long time ago it was a little market with an upstairs apartment; there was a faded sign for some kind of tea on the east wall. For at least the last three decades it's been a dwelling house. It seemed the people in it were always trying to get it fixed up nice and never quite finishing the job. Then a new owner began the curious process of sheathing it in "tin" (as in "tin roof"), which you can see in the photographs. It is now the only galvanized house in Northwest Portland. An architecturally learned visitor from the East, to whom I pointed it out, scarcely flinched. "Interesting," she said, "very postmodern."

Page 86

July 1987. Between 24th and 25th on Thurman.

I was with Roger when he made this picture. I always thought these doors and stairs — never opened, never climbed — mysterious and captivating. This house, known to my children as the Ghost House, turned its back on Thurman, facing a little dead-end street off Vaughn; which made it all the more strange and ghostly.

Page 87

August 1985. Between 24th and 25th on Thurman (the same house).

Standing outside these windows I realized I was looking into a time capsule. The TV tray, the old bread box, the newspapers and cardboard boxes, were in a state of suspension. Through the lens of the camera the windows looked like framed collages, reflecting the outside, revealing the inside.

One of the trees has been cut down, due to rot, I believe; the house has been restored from the foundation up. It is no longer a residence, but houses several businesses. I consider it one of the happy

The "Ghost House," 1993.

stories of change on the street. After all, it didn't become row houses.

Though happy that the house was so handsomely and soundly restored, I'm sad that often the only way to save a big, fine house is to use it commercially. It's a bit like saving a body without the soul. Some row-house developers are soulless profiteers, and many row houses are cheaply, badly built, but there's one thing about row houses: people live in them. Couples, families, kids, old folks, dogs, cats, goldfish. They don't go dead every evening at five. This old beauty is still, every night, the Ghost House.

Page 89

August 1985. Thurman Street Bridge.

The bridge crosses Balch Creek and its steep, beautiful draw. Back then the whole area was known as the Old Balch Place. Danford Balch came west in 1847 and took up a 640-acre land claim with a cabin on Balch Creek. He was the first man to be hanged (legally) in Portland. That was in 1859. O Pioneers!

Page 90

August 1985. Under the northeast end of the Thurman Street Bridge.

These are the stairs that descend from the north side of the bridge into Macleay Park below. In retrospect, it seems that the photograph would be as interesting without my shadow. But it does lend mystery. I was wearing a hat that day, but not a top hat, as the distorted shadow suggests.

Roger insists that it really is his own shadow. I have to believe him, but my private theory is that this is a very rare kind of picture, the photograph of the shadow of a ghost — possibly old Balch?

Page 91

March 1987. In Macleay Park.

The late Louis Bunce, the well-known painter, who returned to Portland after a period of living in New York City, once said to me in describing the atmosphere of the Rose City, "Nature flows up and down the street here." I felt this series of photographs needed one that would convey this infusion of nature into the human world. My first efforts were aerial shots from the bridge looking down into forested Macleay Park, a scene that provides a distinct break with the city atmosphere. But these were unsuccessful, so I departed from my rule of photographing at street level. I descended the stairs from the bridge and walked for two minutes into the park. Surrounded by fir, hemlock, and cedar trees, with the voice of Balch Creek whispering to me, I took this photograph.

During the years I lived in the neighborhood the park was like a personal retreat, a wooded, quiet zone just minutes from my door. I'm glad it made its way into our book.

Macleay Park is one corner of Forest Park, the vast semi-wilderness at the upper end of Thurman Street. If you walk on up this trail you can walk on through forest for thirty miles. This picture is, by chance, the very spot where in 1960, on her first walk on this magical trail, my eldest daughter, age two, in a pink dress, fell into the creek and was rescued, dripping but delighted.

Page 93

October 1986. Thurman and 32nd. *The text is from the* Gita, *2:28.*

The antics of these school kids waiting for the bus reminded me of my own school days in southern Oregon. A few minutes before I took the photograph, one of the boys had taken a lighter from his pocket and ignited some crumpled notebook paper — "To keep warm," he said. When I explained what a tall dude with a camera was doing in their territory, a girl pointed to her house, which she said was built in 1907. She said proudly that the man who designed the St. Johns Bridge and the Golden Gate Bridge had lived there. "When we moved in, there was a lot of sheet music from the 1940s in the house," she said, "but I can't play any of it."

Page 95

August 1985. Thurman and 31st.

One of the beautiful old houses on upper Thurman Street.

Roger has said that this part of the street, which used to seem almost deserted to him, has changed in the last few years, largely because of the mountain-bike crowd driving up and parking all along the street

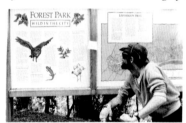

Up in Forest Park.

so they can tear around in Forest Park. In my view, they are a tit-for-tat replacement of the motorbikers who used to roar through at all hours when Leif Erikson Road was open to cars. Fast traffic has lessened, but there are more joggers than there used to be; fewer big dogs, more cats. In rainy weather it's often very quiet. When the sun shines all the people come out and weed their gardens and say, "What a lovely day!" to each other. The children of the neighborhood go in long cycles — there are years when they all seem to be in strollers; years when they all seem to be in high school; years when there aren't many of them; then another flowering of strollers and tricycles and little plastic cars with fat wheels....

Page 96

September 1987. Thurman and 34th.
Text overheard; see note to next plate.

The low wall running along the street here now has a plaque and tile mural commemorating the centennial of the Willamette

Heights neighborhood. In the yard above the steps currently stands a lawn sign reading "Hate Free Zone."

We had lived here for years before we found out the neighborhood had a name. Till then we had just said, like everybody else on the street, that we lived "above Monkey Ward's." Most of Willamette Heights was developed between the 1890s and the 1920s; at least one house goes back to the 1870s.

Page 97

September 1987. Thurman and 34th.

The text to these pictures was spoken by the digging crew as they stood, just as in the photograph, staring with fascination into the large, square hole they had made.

I overheard a good deal they said, as they worked away for weeks and weeks digging and backing and filling and replacing old pipes and mains. Construction crew men often have to shout over the noise of their machinery, and also, working together closely as they do, I think they tend to forget anybody else is around. I would be sitting out in the sunny weather reading or writing or sewing, and find myself listening helplessly to very interesting tales about what my old lady said last night or what Joe did next. It was as good as any soap opera, and the characters were nicer.

Page 98

November 1986. Thurman and 32nd.

As I approached the bus stop where this woman was waiting, she pulled her red cap down over her ears, looked away, and began slowly pacing the sidewalk. Instead of approaching her directly I climbed the front steps of a nearby house and photographed through the tree. After taking several shots I descended the steps and was preparing to leave. To my surprise she came over and asked what I was doing. I explained our project, and she began giving me information about Thurman Street. "There used to be a trolley line on this street. Before that there were a lot of horses and wagons. There was a clay quarry up the hill." She stopped short and furrowed her brow. I wasn't sure what to expect. "The problem," she began, "is that we don't want undue attention brought to this area. Developers will come in and overbuild and destroy the neighborhood." This was a couple of years before the first row houses were built on Thurman.

Several weeks later at the same intersection I met a man who was carrying a small shorthaired dog. We greeted each other and began talking. He seemed optimistic about the future of the neighborhood. The new International Trade Center going into the Montgomery Ward building would increase property values and business in the area. Thurman Street, which he described as in a slump, would experience a boom. Our discussion was cut short by the squirming of his dog, who had grown restless with our conversation. "Thurman Street has a lot of history!" the man said in parting. I was left wondering what interesting information I had missed.

Page 100

1990. Upper Thurman.

Page 101

January 1986. Thurman and 31st.

This picture exemplifies nicely what Roger said above about how the trees and shrubs tend to engulf the houses, or make them look like treehouses, on upper Thurman.

Page 102

1993. Thurman at Gordon Street. *The text is from the Gita, 15:3. One of the neighborhood's loveliest gardens in spring.*

Page 103

December 1985. Upper Thurman.

I was attracted to the texture and detail of this wall and rock garden, which I photographed variously during different seasons. I like it best as a background for this highlighted, calligraphic tree.

Page 105

May 1986. On the Thurman Street sidewalk west of 32nd Avenue.

The poem was written to commemorate a beautiful and widely loved tree which stood in front of our house but not, alas, on our property, so that we could not prevent its destruction. No picture seemed so suitable to accompany it as this tiny seedling making its way, however briefly, up out of steel and concrete into the light and air.

Page 107

November 1987. Looking up 32nd Avenue from Thurman. *The text is from the Gita, 4:5.*

Early one morning I spotted this schoolboy coming down 32nd Avenue to the bus stop on Thurman. He still looked a little sleepy. In

spite of being interrupted in his reverie by an imposing stranger with a camera, he managed a peaceful, bemused expression. In addition to the portrait, the photograph reveals the general atmosphere of the neighborhood.

Page 108

November 1988. Thurman and 31st. *The text is from the* Gita, *11:51.*

The Thurman Street Fountain *(built to commemorate the first half-century of Willamette Heights)* has three drinking places: a bubble-up for human beings, a deep trough for horses, and (around on the outside, low down) a little trough for dogs. It is such a significant landmark of the neighborhood that we felt a photograph of it was a must. We wanted another picture with children in it, since there are many of them on upper Thurman, and the lovely family pictured here agreed to pose for me in exchange for a portrait. We had a lot of fun doing the shoot, which ended in a leaf fight in the middle of someone's yard.

Page 109

June 1987. Thurman above Gordon Street.

Many times over the years have I, or my husband, or our children, walked past this neighbor's house and said "Hello!" to him and to his two dogs, who used to run out and bark bravely, but gradually became very dignified and sedate. And we don't walk by as often, or as quickly, as we used to.

Page 110 and 111

Winter 1987. Upper Thurman.

Even some of the garages on upper Thurman have dignity, simplicity, and elegance. They are silent absorbers of our lives, who may faithfully swallow a car or two each night and spit them out again in the morning. Or perhaps they have become reliquaries for things their owners couldn't live without, which are now discarded, stored, forgotten.

Page 113

January 1986. Intersection of Aspen and Thurman.

I went out early to enjoy the snow that had fallen overnight. The magical atmosphere it creates is especially appreciated in places like Portland, where rain is the norm. As I climbed upper Thurman, the snow was getting deeper. I stopped at the intersection of Thurman and Aspen streets. Forest Park, the largest city park in the world, stretching over miles of hills, begins just around the bend.

I was attracted to this site by the linear patterns: the tire track, the curb and guardrail, the wires and the branches. The level of luminosity was low, so I waded into the foot-deep snow between the two streets and set up my tripod among the frosty bushes. Getting a firm footing for the tripod was difficult because of the slippery conditions and the fairly steep slope. Once set up, I was pleased with what I saw through the lens. I adjusted the composition, placing the white triangle of the distant garage roof in the upper center for a focal point. As I was attaching my cable release, I heard voices behind me to the left. I glanced over my shoulder and saw the sledders coming down Aspen Street.

I was immediately elated and filled with anticipation at this opportunity. These are the moments that give me, as a photographer, encouragement and faith that I am part of a larger process than I am aware of. There is no other way to account for such "luck."

I planted my feet, crouched, steadied myself with the help of a branch, grabbed the cable, poised my finger on the release button, and became the eye of the camera focusing all my attention through the lens. For a long, impatient moment I waited, monitoring the approach of the sledders by listening to the hiss of the runners growing louder. They were getting very close, gaining speed. One of them came into view on the left and arced across the street.

Don't shoot yet. You only get one try. Wait till they're both in the picture. Wait. Will the first one still be there? I hope. I hope. Yes! There. Now. Got it!